IMAGES
of America

GREECE

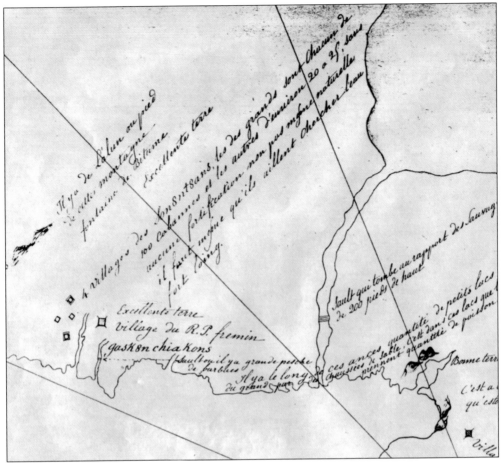

Etienne Brule was the first white man known to have been in the Genesee area, sent as a scout in 1610 to map the region for Samuel de Champlain. Champlain's 1612 map was the first map showing Lake Ontario. However, the map reproduced here, drawn by the Sulpician priest Rev. Fr. Rene de Brebant de Galinee in 1670, is the first map to show the south shore of Lake Ontario from actual observation. The priest came to Totiakton near Honeoye Falls in 1669 with the explorer La Salle.

Galinee's map shows the coastal areas of Lake Erie, Presque Isle, and the rivers Genesee, Niagara, and Grand (in Canada). It refers to the Neutral and Erie Indians, who occupied the Niagara Peninsula and areas extending to the Genesee River until 1655, to areas of rich soil, and to the Irondequoit Creek and the falls on the Genesee (casconchiagon), where many delectable flatfish (les barbues) were found. All along the shoreline of present-day Greece, the priest described "many lakes separated solely by patches of sand [sandbars] where the Senecas take a large number of fish."

Galinee noted that the two large Native American villages, Totiakton and Ganagaro, were large with more than 100 cabins, while the smaller Native American towns had 20 to 28 log dwellings. He called Totiakton "Fr. Fremin's village" because Fremin was stationed there from 1668 to 1669. Fremin and his aide, Francois Poisson, were the first white residents of Monroe County. Their humble 1669 chapel, La Conception at Totiakton, was the county's first structure built for Christian worship. The lakes shown on this map are Lake Erie (upper right) and Lake Ontario (bottom). The wide river on the right is the Niagara River.

IMAGES
of America

GREECE

Shirley Cox Husted

ARCADIA
PUBLISHING

Published by Arcadia Publishing
Charleston SC, Chicago IL, Portsmouth NH, San Francisco CA

Printed in the United States of America

Library of Congress Catalog Card Number: 00110176

For all general information contact Arcadia Publishing at:
Telephone 843-853-2070
Fax 843-853-0044
E-mail sales@arcadiapublishing.com
For customer service and orders:
Toll-Free 1-888-313-2665

Visit us on the Internet at www.arcadiapublishing.com

To my Greece relatives, descendants of William Cox and Mary
Johnson, Edward Cox and Martha Whittier, Seth Hawes and Susannah
Priestley, Niles Hawes and Hattie Jordon—ancestors whom I have
never known except through the magic of photography. I wish that I
could have known them personally, for memories
of relatives loved and lost are ever precious.

CONTENTS

Iris.

Wild iris, water lilies, and other wild botanical delights thrive in the wetlands of Greece along the southern shore of Lake Ontario, just west of the Genesee River. Marine life, birds, wild beasts, insects, and civilized creatures now happily coexist on land acquired from the Seneca Indians. It was the Native Americans' intention that white settlement would not continue past the river. In 1788, the line was pushed westward as far as the Parma-Hamlin-Clarkson town line, called the Indian Line on early maps. This act of unfair skullduggery by government agents took thousands of acres from the Seneca Indians in return for the erection of Ebenezer Allan's mills in what is now part of downtown Rochester.

Through that cunning bit of deception, the old town of Northampton was created on the 84,000 extra acres of the Mill Seat Tract that was added to the Phelps & Gorham Land Company's purchase. From this gigantic 12-by 24-mile tract of rich acreage, the town of Gates was taken in 1812, Rochester was split away in 1817, and Greece was subdivided from Gates in 1822. In 1915, with the blessing of industrialist George Eastman, a narrow strip of land bordering the river was annexed to the city. Thus was born present-day Greece, Monroe County's largest suburban metropolis.

Acknowledgments

Most of the photographs in this book are from the files of the Parma town historian, the Honorable Gordon A. Howe, Sheriff Albert Skinner, the Greece Historian Office, the Greece Historical Society, the village of Hilton historian's office, the Rochester Public Library, and the Rochester city historian's office. Also greatly appreciated are the pictures provided by Jolyon Kaiser, Denny Wright, the Reverend I.V. Lloyd, Walter Sassaman, Loretta Bauer, David Crumb, Rick Hooper, Marion Schepler, Leith Wright, Mary Townsend, Violet Cooper White, Keith Kroon, Kathleen Hershey, Kirk House, and the Curtiss Museum in Hammondsport. Works Progress Administration scrapbooks and federal highway records were the sources of many of the street pictures.

Important research assistance came from Virginia Tomkiewicz, Lorraine Beane, Alan Mueller, R.A. Bergeron, Donald Stilson, Carol Fede, William N. Hosley, and Marie Poinan. Donald and Nancy Wright of Dancy's Photo Memories, Inc., beautifully restored several damaged photographs. Arcadia Publishing's staff specialists are also thanked for their help.

INTRODUCTION

We float in mystic space, an infinitesimal speck in a vast solar system, this planet called Earth. How proud we can all be that the miraculous cameras and film that made it possible to share space explorations and record their historic moments of discovery came from a city by the Genesee River and a place called Greece, New York. Here, workers from Greece and its surrounding areas have produced some innovations that changed the world. Our relationship has been a good one as we worked together, played together, worshiped together, sacrificed together, and learned together. It has made "Greece" and "Kodak" names that are respected across the world. That happy relationship is the theme of this book.

If you would like to experience a quick taste of today's Greece, drive down Long Pond Road. Bisecting the heart of this Monroe County township of nearly 100,000 people, Long Pond presents views of the ancient pond for which it was named, a school, the town hall, a museum, a hospital, parks, shopping plazas, a sprinkling of old country houses nestled on what remains of ancestral acres, churches, funeral homes, apartments, the Grange Hall, a highway department complex, and the pleasant homes that are the lifeblood of this Rochester, New York, suburb. These elements were made strong by the presence of the Eastman Kodak Company. The town symbol features the Charlotte Lighthouse because Charlotte was in Greece until 1915; it also features a lightning streak, symbolizing the power of Greece, and a Greek key border. The town's name is a tribute to the old-world nation of Greece, an eternal symbol of democracy, honor, and sports excellence.

Nearly 300 years ago, Charlotte was the site of a little river community where William Hencher brought his family in 1792, enlisting the help of friendly Native Americans to thatch his homestead British style. Charlotte and pioneers from neighboring areas prevented an attack during the War of 1812 by deceiving the invaders. There, the old Latta house, one of the city's oldest, still remains as a reminder of the pioneering Latta family's efforts to assist the Underground Railroad. Several other picturesque 19th-century homes provide delightful reminders of Greek Revival and Victorian housing. Still prospering are Buckman's Dairy and Abbott's frozen custard stores, begun by Arthur Abbott in 1902. Fine foods are still served at the Dutch Mill, a restaurant-bar named in honor of early German residents. A marina established by the Skinner family and other small businesses still contribute to the economy of the town and the pleasure of its residents.

Countless new business establishments service the burgeoning population. The most valuable Greece property lies along Ridge Road West, where a lot now sells for $1 million or more. Gone

are the dahlia farm at West Greece, the Lyon's Den restaurant and bowling center, Jack Tannis's gas station, Olsen's gladiolus gardens, the former town hall and old Grange Hall, the Baptist church, and Ray Kraft's Red and White Store. In their place, one of the state's best shopping plazas attracts the attention of customers from Canada as well as from a large portion of the populous metropolitan Rochester area. Fondly remembered are Marty McIntyre's; the gigantic hotels, bingo parlors, and restaurants at Ontario Beach; and big band dance music, Farmer's Picnics, and the other pleasures at Manitou Beach. We miss Edward's, Sibley's, and McCurdy's fine stores; Marty Reichenberger's at Barnard's; the Windmill Grocery at Greece Center; and a host of other small businesses.

Take a quick trip down Mount Read Boulevard, past the site of the oldest rural Roman Catholic parish in New York State, perched atop Paddy Hill and named for that area's early Irish farmers. Drive on past an attractive blend of older homes, new shopping plazas, and apartments. Drive past industrial plants and food service establishments that draw customers from miles around. Modern schools nestle on intersecting roads, anticipating even better improvements in the 21st century.

Fireworks and band music still attract crowds to Charlotte; fishing and boating are still popular on the lake and river. Currently, there is talk of reinstating the ferry to Canada. Edgemere Drive will take you past the shore homes that evolved from summer cottages and Barry's elegant Crescent Beach Restaurant, a glorious sight when its sparkling white lights illuminate the skies during the holiday season. At Braddock Heights, the town marina has become so large that its countless boats can easily be spotted from the nearby lakeshore expressway.

There are employment opportunities galore in Greece. Although Eastman Kodak has downsized, it is still the county's largest employer, closely followed by Wegmans, one of the nation's finest grocery chains, distinguished locally for providing strong financial support to Roman Catholic education. Not long ago, Kathy Turner of Payne Beach became an Olympic medal winner in speed skating, attracting worldwide attention.

Greece has always had a spirit of pride, with a strong political leadership unequaled by any other local municipality outside the city of Rochester. "Resourceful" might be the word that best describes this ever growing community. Greece is a home of good neighbors and a good place to shop and to find recreation.

Because North Greece area residents on the western side of Greece orient toward their Westside neighbors and voted to become part of the Hilton Central School District in 1949, the ever pleasant interrelationship of Parma and Greece—as well as that of Greece and Charlotte on its eastern border and Greece with Rochester—is emphasized in this book. Neighboring communities inevitably contribute to each other's economy. The North Greece Fire District extends into Parma. The Parma and Greece United Church of Christ includes residents of both areas in its congregations, as do several other Greece churches. Shopping malls and other businesses attract customers. The Kodak company, fire service, medical services, and shopping facilities unite us. Greece highways provide access to the expressways. It is the largest town in Monroe County in population, area, and recreational water bodies along the shores of Lake Ontario, including its marshlands, ponds, and bay.

This book provides a graphic glimpse of the glory that was Greece, showing both the greatness of today and the promise of tomorrow. Greece: always the home of many fortunate Americans, proud to be Grecians, a picturesque and pleasant place where one cannot help but be happy to be alive. Greece: where life can be a perpetual banquet.

Greece is a very special place to me because it was the home of my parents and grandparents for a portion of their lives. In that respect, I am a daughter of Greece. As I admire its growth into one of the most important townships in New York State, I know that it will always continue to hold a special place in my heart.

—Shirley Cox Husted

One

ALONG THE
GOLDEN SHORES

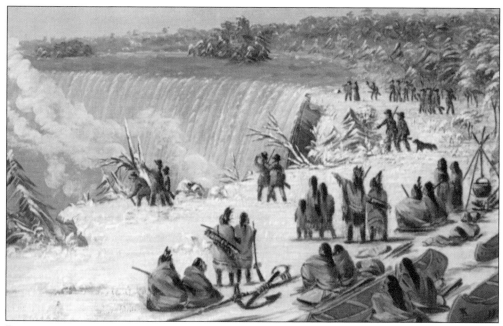

By A.D. 1400, small Native American communities were scattered from the Niagara River to Canada along Lake Ontario's south shore. This Christmas card sent by Charlotte and Barber Conable features a reproduction of George Catlin's painting of La Salle's Native American contact at Niagara Falls in 1678. Traveling with La Salle, the intrepid Franciscan Recollet Fr. Louis Hennepin discovered Niagara Falls that December. He built a Franciscan chapel near Irondequoit Bay in 1681, the first place of Christian worship in the Rochester area.

Native American fort sites (villages) that are believed to be prehistoric were found on the riverbanks in Maplewood Park and Seneca Park. This postcard view of a trail in Seneca Park is typical of Frederick Law Olmstead's plan for Seneca, Maplewood, and Genesee Valley Park—all designed with the intention that their scenic natural landscapes and foot trails would provide a sharp contrast to built-up city landscapes, as did his famous Central Park in New York City.

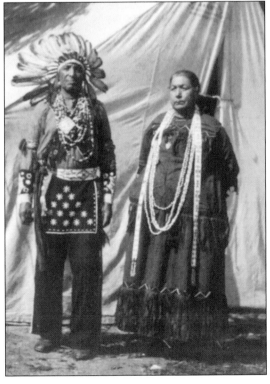

Native Americans appear in Plains Indian attire at a Maplewood Park demonstration in this Bauer photo postcard from the Greece Historian Office. Fourteen camp, village, and burial sites have been identified in Greece. Most of them are located along the river or lake and near Ridge Road and Ridgeway Avenue. Chief Freeman Johnson of Greece, a Seneca sachem, participated in dedication ceremonies for a Native American site marker at 28 Kuhn Road. Archaeological finds of pottery, stone, and bones there in 1912 provided proof that the site had been used as a campsite as early as A.D. 1400.

There were millions of fish and eels in the lake, thousands of frogs in the ponds, and, until the 1600s, a multitude of beaver dens. Beaver pelts were the lure that first brought Native Americans, trappers, and explorers to the Genesee area. Used in making felt for gentlemen's hats, their pelts were highly prized abroad, and plenty of them could be found in Greece. No other place on Lake Ontario had as many ponds.

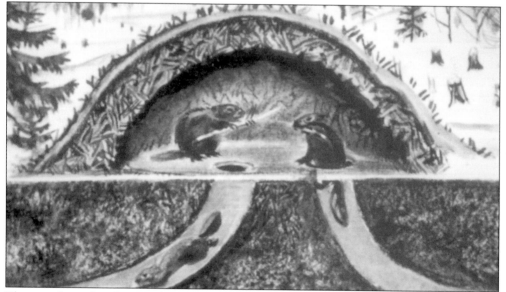

The complicated underwater homes built by beavers are graphically shown in this photograph. Similar underwater domiciles are made by muskrats. Muskrats, beavers, otters, fox, and deer possessed valuable pelts that made the several month's journey from Montreal to the Native American country profitable because these wild animals were so plentiful. At first, only French Canadians came, desiring control of the Great Lakes area to possess the land, its furs, and the allegiance of its native residents. Devout priests also came seeking converts. Two forts were built—one at Niagara, between 1726 and 1727, and one at Oswego in 1727, strategic locations past which all trade to Albany and Canada had to pass.

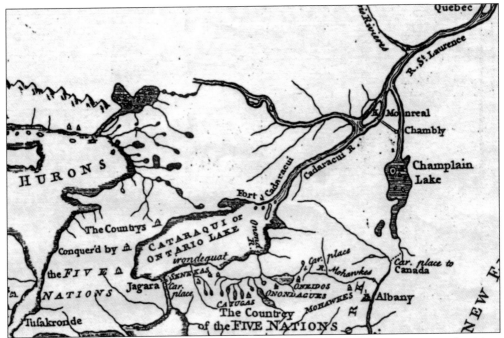

Among early fur-trading firms prominent in Canada was the Kruger Company; one early visitor to Braddock Bay even noticed a Kruger Company canoe beached alongside Native American canoes. Fr. Jacques Fremin spent most of his days in the Montreal–Three Rivers–Quebec area. There, he headed the Jesuit program in Canada that controlled the beaver trade for a time. He was the resident missionary priest at Ganondagon, Ganagaro, Gandagarae, and Totiakton near Honeoye Falls in 1668 and 1669.

Although chapels were built in the Native American country, Jesuit activities near East Bloomfield, Holcomb, Honeoye Falls, and Victor only lasted a few years, after which the priests were removed in 1683 to ensure their safety. This 17th-century map shows the lands traders, priests, soldiers, and explorers visited. Conversion from the Native American religion to Christianity was difficult and it became impossible to achieve after an invasion by Canada's Governor Denonville destroyed Ganagaro, Ganagarae, and Totiakton in 1687, turning the Iroquois against the French. Because the Native American villages of the upper Genesee Valley had been eradicated, new native home sites were created farther south along the river. In the summer, some Native Americans still came to the lakeshore to establish summer camps, fish, hunt, and gather cranberries and wild strawberries.

The French established a small trading post at Sea Breeze in 1717. Fort Schuyller, a British outpost, was built at Tryon Town on Irondequoit Bay in 1721, ostensibly to trade but secretly used to spy on Native American activities and to gauge their loyalty. In 1741, New York Governor Clarke paid the Native Americans approximately $250 for land rights to most of Monroe County 6 miles east and 20 miles west of Irondequoit Bay.

The invasion of a British army led by Gen. John Prideaux in 1755 finally thwarted French attempts to control the coastline. The bay, known today as Braddock Bay, was named Prideaux Bay in his honor when Prideaux's army of 2,200 men camped there on July 4 that year. A few days later, Prideaux was accidentally killed by an explosion during the attack on Fort Niagara. In 1779, Gen. John Sullivan's army destroyed the remaining Seneca homes near the Finger Lakes and Geneseo. A peace treaty signed at Paris in 1783 gave New York the right to govern. The treaty also enabled white settlers to purchase land rights from the Native Americans and the State of Massachusetts, which also claimed title to the land because of a king's grant to the Massachusetts Bay Colony.

Although less than an acre was needed for a mill, the Senecas were asked to give up 84,000 acres—most of western Monroe County except Hamlin, Clarkson, and Sweden. Seneca women were impressed by the argument that a gristmill would be built on this tract, after which they would no longer have to grind corn into cornmeal and flour by laboriously pounding corn kernels in a hollowed stump for hours. Although Ebenezer "Indian" Allan did built the promised flour mill and a sawmill along the river in 1789, settlement was slow, and the Native Americans and pioneers seldom used them.

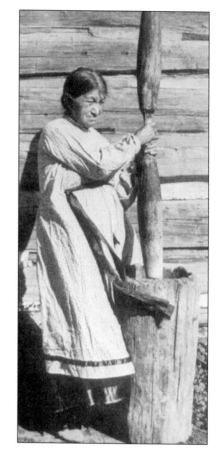

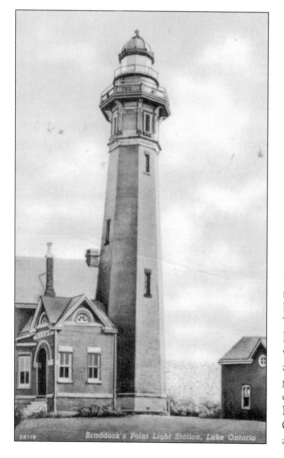

Braddock's Point Light Station, Lake Ontario

In 1805, Charlotte was designated as the river port for the region. Soon, a chain of lighthouses was built along the coastline. The brightest of them all was the Braddock Point Light. In 1822, Greece was created, supposedly named because of admiration for the fight for freedom then going on in that country. Many other old-world names are found throughout New York State. Parma, Riga, Chili, and Greece were given European names, then a fashionable practice.

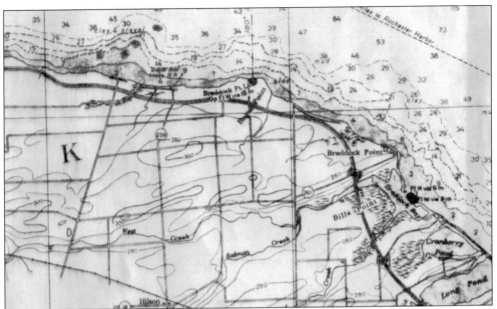

This navigational map of the Greece and Parma coastline indicates the location of Braddock Point in Greece and Bogus Point in Parma. Braddock Point Light was built in Parma after it was realized that the promontory there extended farther into the lake and provided a better site from which to guide ships to the port of Rochester. Thus, because of a government boondoggle, the Braddock Point Light is not on Braddock Point.

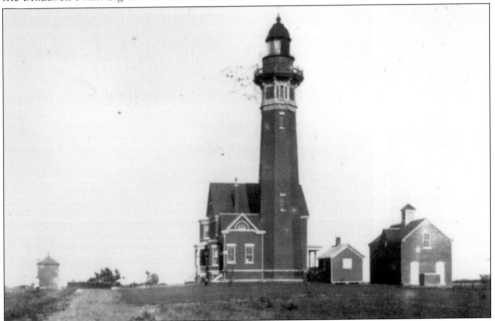

Every lighthouse had to be built in a slightly different manner so they would be identifiable to mariners. After cracks developed in the Braddock Point Light's tower, the top of the tower was removed for reasons of safety. The recent addition of a squatter tower does not duplicate the towering majesty of the original lighthouse. Most of the land originally in front of the lighthouse has eroded away.

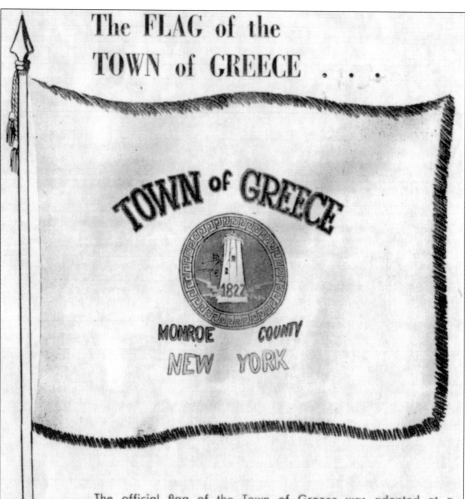

The FLAG of the TOWN of GREECE . . .

TOWN of GREECE

1822

MONROE COUNTY

NEW YORK

The official flag of the Town of Greece was adopted at a meeting of the Town Council on August 17, 1954.

Centered in a field of white is an emblem, designed by J. S. Perticone and depiciting the old lighthouse at the mouth of the Genesee River, which was built in 1822 — the same year the town was established.

The circle represents the shield of the warriors of Ancient Greece and the border is of characteristic Greek design. The lightning is symbolic of strength and the colors — terra cotta, golden yellow and black — are those used in old Greek pottery and artistic decorations.

The Charlotte Lighthouse was chosen for Greece's town emblem because of its importance to early Greece history.

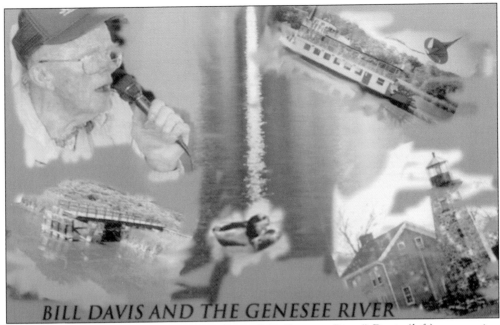

BILL DAVIS AND THE GENESEE RIVER

Under the enthusiastic leadership of William "Mr. Genesee River" Davis (left), restoration of the Charlotte Lighthouse and the adjacent keeper's house began in 1983. After Davis successfully urged the community to "Remember the River," "River Romance" programs followed as thousands discovered the beauty of the Genesee River and Charlotte, a village named in honor of Charlotte Troup, the daughter of its first land agent. The illustration in the bottom left of this image shows the old dock at Turning Point Park, where folks boarded the coal and passenger ferries to Cobourg, Canada, from November 15, 1907, to April 30, 1950.

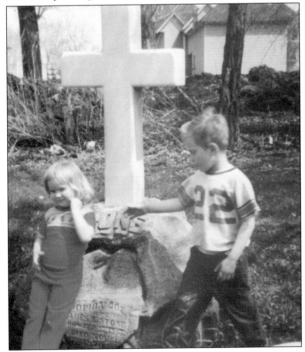

Brett and Rosemary Husted stand by the Stone plot in Charlotte Cemetery, which incorrectly identifies James Stone as the first child born in Rochester. Also in the cemetery is the grave of the famous daredevil Sam Patch and members of several pioneering families. Just beyond Charlotte in Holy Sepulchre Cemetery lies the grave of Francis Tumblety, one of the suspects in the Jack the Ripper serial murder investigation in London in 1888. He manufactured and hawked worldwide a pimple-banishing cream that made him famous.

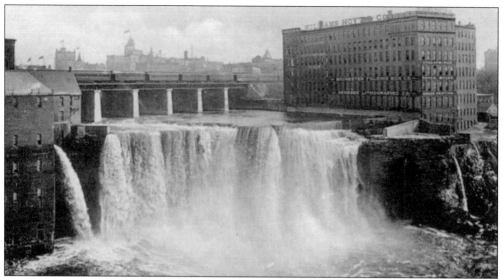

A New Jersey stuntman named Sam Patch jumped to his death here, over the high falls of the Genesee near Central Avenue. The fate of a pet bear that usually jumped with him is still a mystery. Patch was famous for the saying, "Some things can be done as well as others." However, when he decided to jump on Friday, November 13, 1829, he learned differently. After lingering overly long at a barroom, he fell sideways as he jumped, apparently dislocating his shoulder when he hit the water, which made it impossible for him to swim. His body washed ashore the next spring at Charlotte where he was buried.

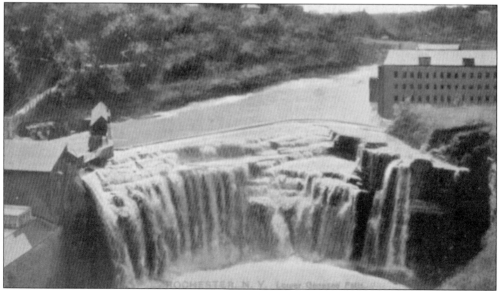

Near McCrackenville, where two falls impeded navigation, the first surveyed road west of the river became a reality in 1799. It led from the Atchinson Settlement in Parma to the Kodak Park area, where one branch became the Hanford Landing Road and a second crossed diagonally to McCrackenville, connecting all three settlements. These picturesque 96-foot-high falls near Francis Brown's millrace provided waterpower for riverside industries and are still used as a power source for the Rochester Gas & Electric Company. The Driving Park Avenue bridge is nearby.

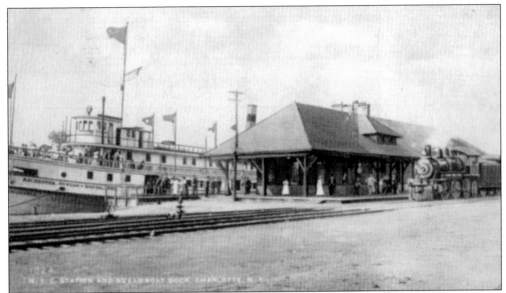

This postcard view shows the New York Central Railroad station at Charlotte. Before automobiles became popular, trains offered the best way to travel. Nearby, a British guard held the Latta family captive in their house during the War of 1812, while James Latta's warehouse was emptied of its stores. One of the oldest structures in Monroe County, the house still stands on Lake Avenue. Escaping slaves were sheltered in Latta's warehouse nearby during Underground Railroad days, c. 1830–1860.

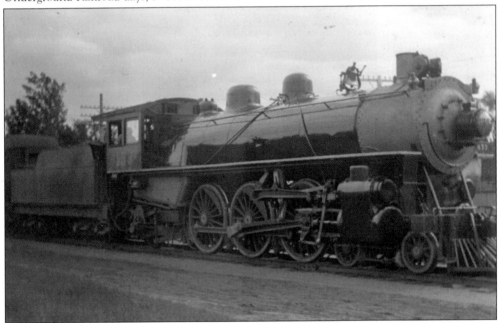

This steam engine was a familiar sight on the New York Central Railroad. Since Charlotte was the closest port to Canada on the Great Lakes, many loads of coal arrived there, awaiting transport to Canada on the coal ferries. The first depot at Charlotte burned in 1905. Today, the Charlotte Lighthouse stands on the high bank, overlooking the railroad, on the property where William Hincher brought his family in 1792.

This *Hilton Record* advertisement announces reduced rates for trips via New York Central lines. Riders could go to Ontario Beach at Charlotte for 35¢, to Rochester for 50¢, or to Niagara Falls for $1.60. Round trips to Boston, Massachusetts, cost $11, and it was possible to ride west all the way to the Pacific Coast.

REDUCED FARES

NEW YORK CENTRAL LINES

Boston, Mass. $11.00
Round trip. Tickets on sale Friday, July 11. Return limit, July 25. Stopover in either direction at Pittsfield, Palmer, South Framingham, Springfield or Worcester, Mass., within return limit of ticket.

Pacific Coast and Western Points
Alberta, Arizona, British Columbia, California, Colorado, Idaho, Mexico, Michigan, Minnesota, Montana, New Mexico, Ontario, Oregon, South Dakota, Utah, Washington, Wisconsin and Wyoming. Tickets on sale daily to September 29th.

Ontario Beach .35
Return trip. Every Sunday to August 31, inclusive. Also on Labor Day, September 1. Returning same day.

Niagara Falls 1.60
Rochester - .50
Round trip. Every Sunday to October 26, inclusive. Also on Labor Day, September 1. Returning same day.

Consult local ticket agents for time of trains and other information.

This family is leaving for California. Their keepsake photograph comes from the Mitchell family's collection.

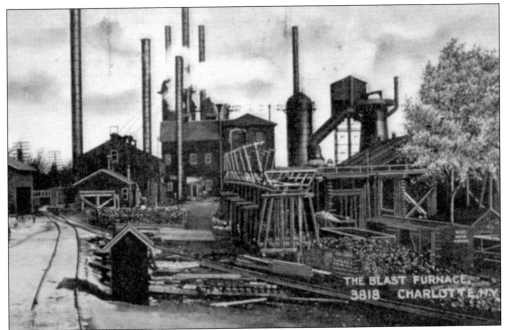

This 1908 postcard shows the blast furnace at Charlotte. A big employer and taxpayer before the days of concern over air pollution, Henry Roberts's Rochester Iron Manufacturing Company firm provided ingots for Rochester industries from 1869 until 1927.

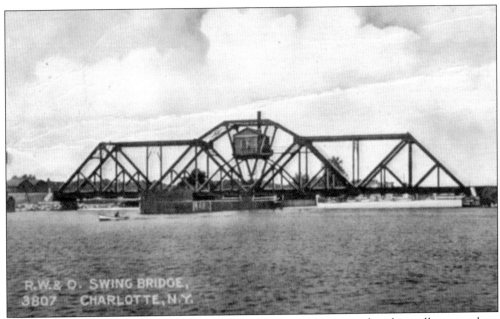

The railroad swing bridge at Charlotte, built in 1905, could be turned aside to allow vessels to pass on the river. Because the bridge has been unused for years, controversy now swirls around who will pay to disassemble it. An earlier swing bridge was installed in 1875.

Fees on imported goods were imposed by customs officials at the customhouse and grocery, a stunning building that later housed the Tapecon Company on River Street at Charlotte.

This image shows the Charlotte library. The automobile and the architecture of the two buildings indicate that the photograph dates from the first quarter of the 20th century.

The former Charlotte High School, built in 1908, was demolished in 1937. The firehouse built in its place sounded out fire warnings on its fire bell for decades.

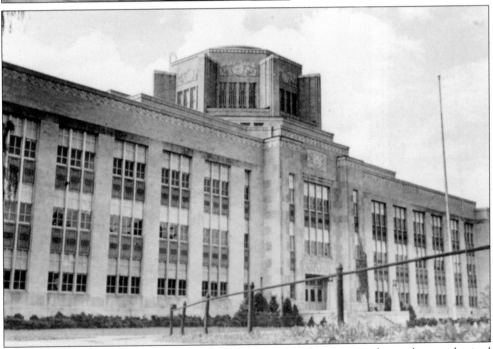

A new Art Deco–style high school, now a middle school, had a maritime design that emphasized its location near the harbor. It was built in 1933.

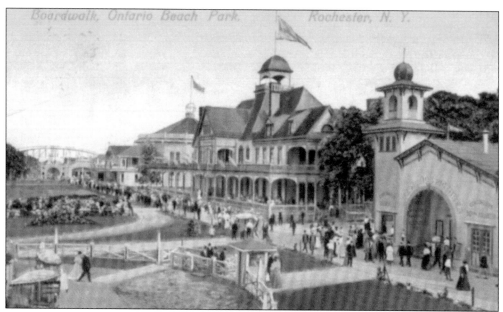

At the end of Broadway was Ontario Beach Park, where a wide boardwalk led past the gigantic hotels, rides, and pleasure palaces at the park. Marty McIntyre's place, the first business on the beach, rented out boats, fishing tackle, and bathing suits. As it grew in popularity, delicious whitefish dinners were served between 1861 and 1872. Spencer House, Capt. John Burns's new hotel that replaced McIntyre's humble establishment, was much more elaborate and included 76 rooms. It burned in 1882 and was followed by the amusement park that gave Charlotte its reputation as "the Coney Island of the West."

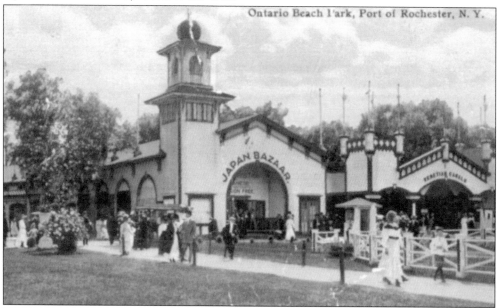

What a pleasant experience it was to walk the boardwalk, to see the Japan bazaar and Venetian Canals, to ride the Breezer, or to watch a dramatization of firemen saving a woman from a burning building. A postcard of that popular enactment was recently sold on the internet, supposedly showing a real fire at Charlotte.

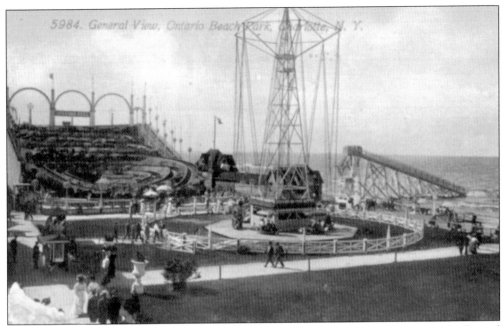

The swings, the water slide, and other rides appear in this image. By the 1980s, only the Denzel carousel and a skee ball booth remained in business to entertain summer visitors, and these were subsidized by the county budget.

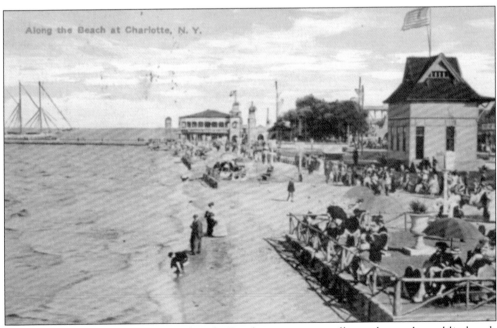

A band shell adjoined the bathing beach. Band concerts are still popular at the public beach and picnic grounds.

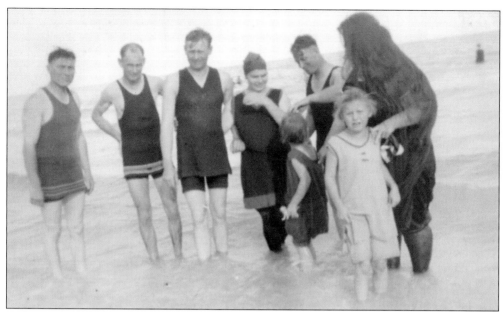

Male swimmers in modest bathing suits pose with a woman who laughingly called herself "the Sea Witch."

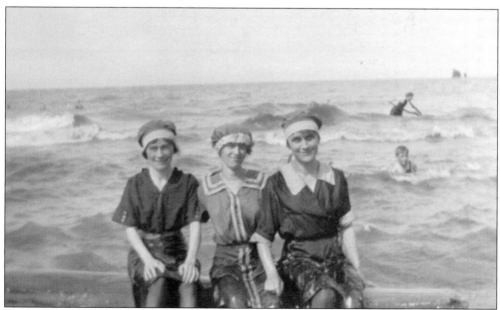

The ladies of the lake appear in this beach scene. It was customary for ladies' swimsuits to reach up to the neckline and down to the knees or ankles. A 1908 law required that "suits for women must come up to the neckline."

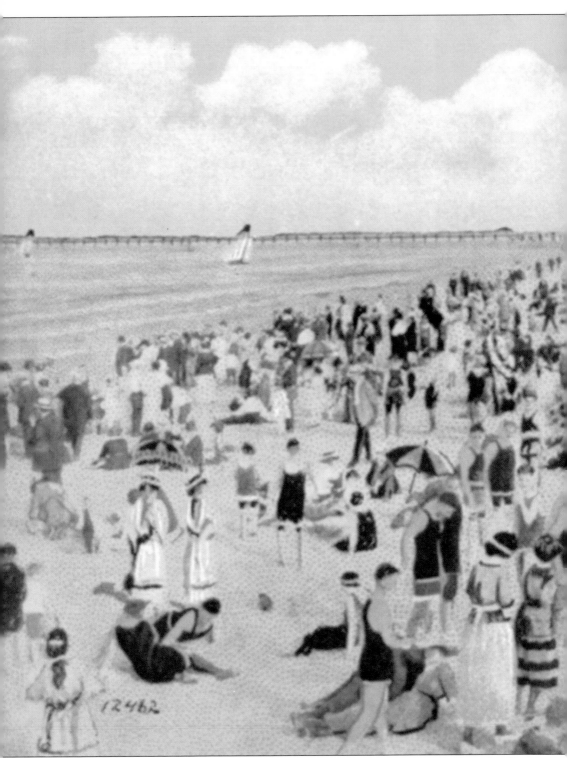

12462

This crowd at Ontario Beach park was typical for a Sunday. The sandy bathing beach was fun for all ages. Umbrellas sheltered beachgoers from the dangerous rays of the sun. Fairchild

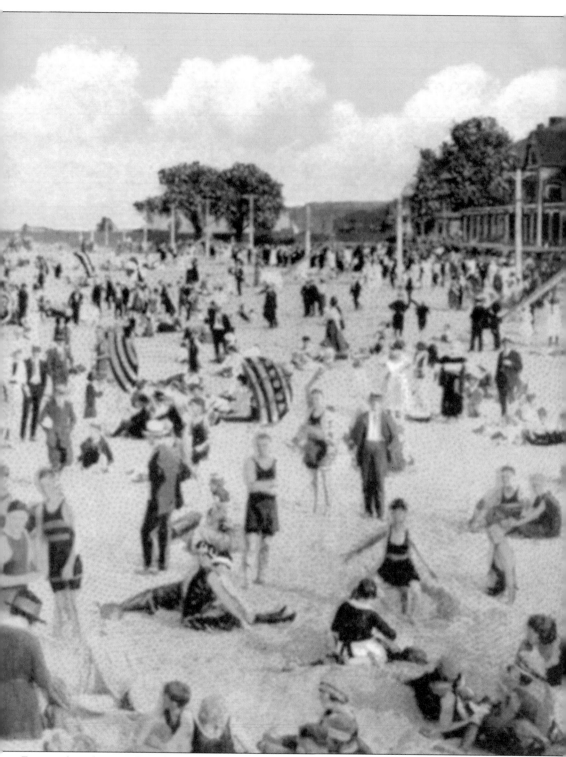

Fritters, hot dogs, and "sodey pop" were popular treats, but nothing seemed more delightful than an Abbott's frozen custard cone. A new bathhouse opened in 1931.

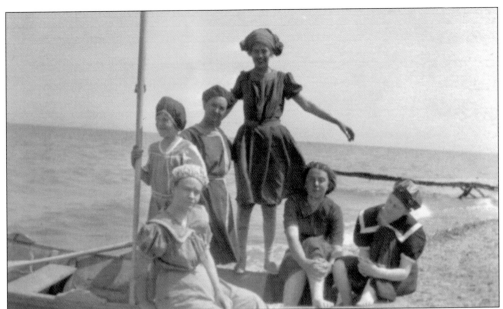

Ship ahoy! Do you want to take a ride? This crew needs a captain! More elaborate vessels now ply the waters, most costing more than $100,000 each. When the Gordon Howe family lived on Edgemere Drive, watching the annual regatta was a pleasurable experience. Selling their house near Charlotte beach was the greatest mistake of his life, Howe said, for he loved to watch the waves roll in.

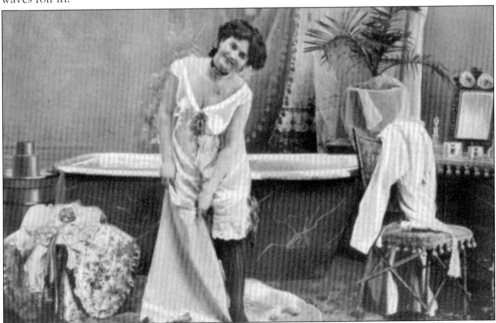

By 1899, there was growing concern about gambling and Sunday baseball games at Charlotte. Open hotel bars on Sundays and the presence of 35 hotels and bars had given the village a bad reputation by 1910. This postcard from 1912, an example perhaps of yesterday's pornography, is one of a series showing a woman bathing. However, in 1912, "Holy Joe" Quigley, the police chief, successfully crusaded against gambling, disorderly houses, vagrants, and loiterers.

28

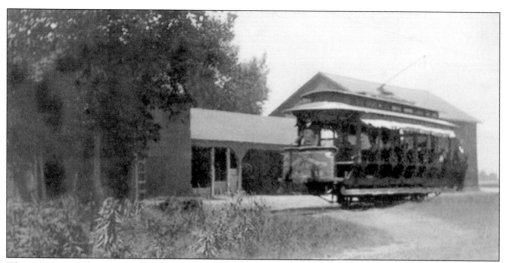

The Manitou Beach Trolley began operation in 1889, stopping at little station houses at the shoreline.

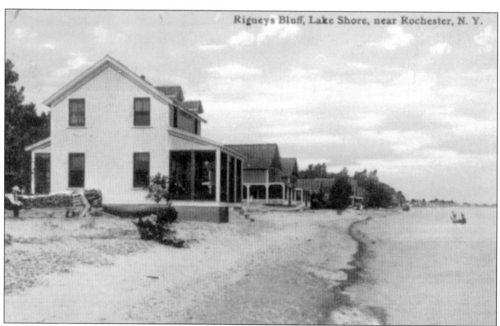

Rigneys Bluff, Lake Shore, near Rochester, N. Y.

These cottages at Rigney's Bluff were typical of hundreds built along the lakeshore. All of that sandy shore that once extended 100 feet or more in front of the homes has long since been eaten away by the restless waves of Lake Ontario. A washout of the trolley tracks near Rigney's helped end the trolley's success. Where the Infants' Summer Hospital once operated, a nursing home now cares for adult residents. Vernon and Girlie Goodwin and many other shore residents crusade for better protection against flooding.

29

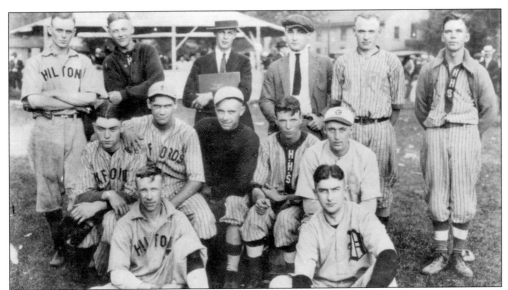

There were almost always baseball games for entertainment at waterside resorts. At Manitou Beach on the end of the trolley line, the Hilton ball team was usually the victor. The picnic pavilion and the dance hall at Manitou Beach can be see behind this c. 1920 Hilton High School team. From left to right, the players are as follows: (front row) Loyd Burritt and John Crook; (middle row) Fenton Coakley, Kenneth Way, Harry McCarty, John Delehanty, and Bert Perry; (back row) Lester Anderson, Carl Oldach, Harry Dailey, Court Lee, Albert Fleming, and Ralph Butcher.

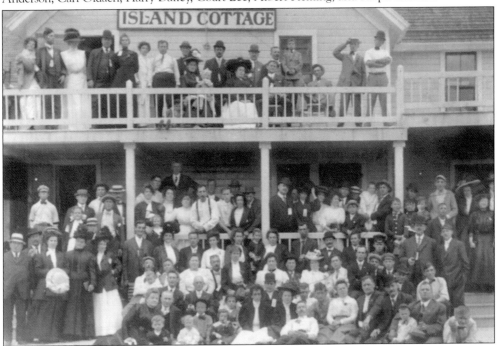

Island Cottage was neither an island nor a cottage, but it was a fine place to dine or picnic. Supposedly, it was nearly surrounded by pond waters in its earlier years. This 1909 photograph is from the Greece Historian Office. The 54th Regiment Band often played at Island Cottage and Manitou Beach events.

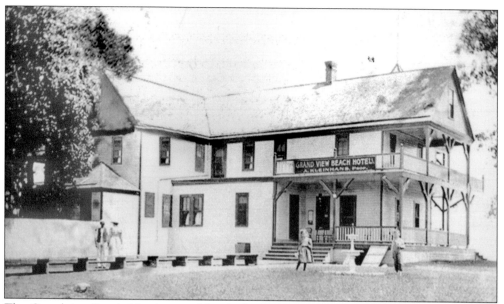

The Grandview Beach Hotel, owned by Anthony Kleinhans, was the largest of a number of "watering holes" along the route of the Rochester and Manitou Railroad, usually called the Manitou Beach Trolley. It transported customers from Rochester to Manitou Beach and back with stops at Tom Streb's East Manitou Hotel, the Springwater Hotel at 3107 Edgemere Drive, the Surf Club (later the Breakers) at Round Pond, Grand View Beach, and Manitou Beach. Tom Streb's East Manitou Hotel was destroyed by arson on September 1, 1992.

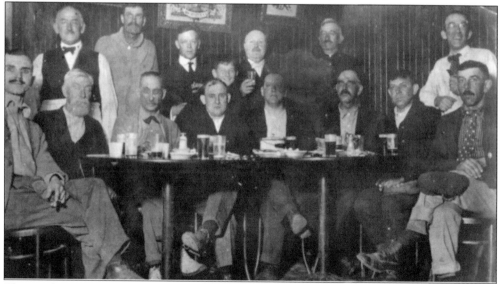

This Limburger Cheese Club photograph preserved by the Greece Historian Office shows Tony Kleinhans at the left rear (wearing an apron). The big hotels depended on the trolley to bring them many barrels of beer to sell to thirsty customers. However, Prohibition and gas rationing eventually forced them out of business, and the trolley went bankrupt. Tony Kleinhans sold his hotel to Mr. Rosenbach, who operated it for a few years. After papers were signed transferring it to a new owner, Rosenbach went to visit friends in Rochester. That night, the hotel caught on fire, and by the time he arrived back at the beach, it was a smoldering ruin.

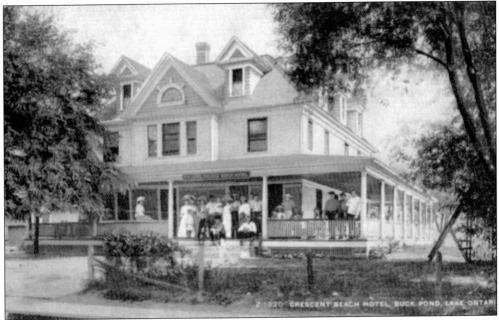

In January 1973, fire destroyed the Crescent Beach Hotel, the second hotel structure at the beach. It had been operated by the Lewis and Geis families. This reproduction is from a colored postcard in the collection of the Greece Historian Office.

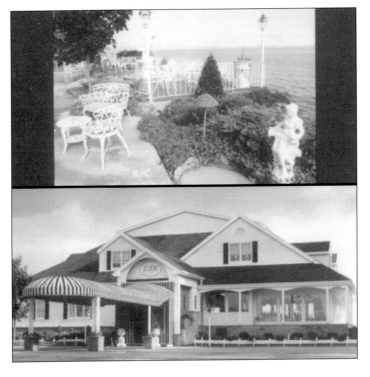

Rebuilt and reopened, Joe and Gloria Barry continued to welcome customers to their elegant restaurant at 1372 Edgemere Drive. The front windows and outdoor patios offer customers a sweeping view of beautiful Lake Ontario. The shimmering waters of Buck Pond lie south of it, an unforgettable sight at sunset. Hundreds of valuable Christmas decorations were threatened by a fire in 1999, closing it down temporarily.

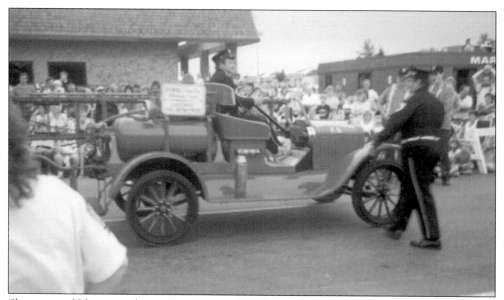

Shown at a Hilton parade are the Crescent Beach Fire Department's antique 1919 American LaFrance chemical engine, built on a Model T Ford chassis, and their antique hose cart. Before water lines became a reality, there were many fires at the hotels and beachside cottages. Controlling a fire when winds blew off the lake was difficult and almost impossible, even with chemicals. The Crescent, the Grand View, and the Braddock Heights companies became a joint district—Lake Shore—in 1957.

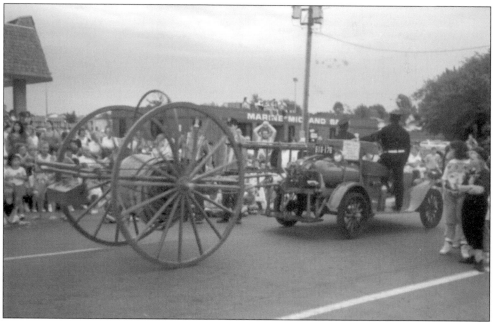

One of the town's most memorable fires was the destruction of the Holiday Inn, built by Schraff's on Ridge Road opposite Stone Road in 1978. Ten people lost their lives in that horrible conflagration. Charlotte had other disastrous fires almost every year from 1880 to 1893, and scores of fires, many of them at hotels, have been recorded. Putnam Mills at Podunk had burned in 1864. There were 88 blazes at Charlotte before it was annexed to the city.

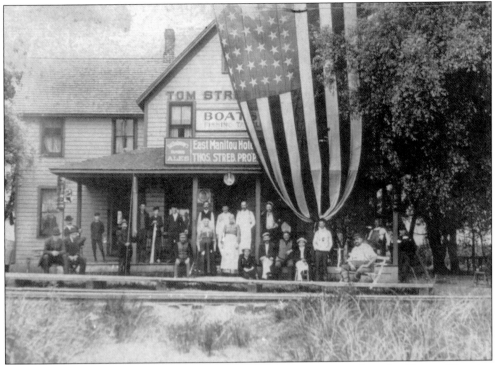

Trolley tracks can be seen in the foreground of this wondrous picture from the Greece Historian Office. It shows Streb's East Manitou Hotel at Braddock Heights, c. 1910.

The Braddock Bay State Park and the town marina now brings hundreds to "the Heights." Here, young males sometimes humorously called themselves "the Bay Rats," a term of endearment, as was the name "Braddock Bay Beavers," chosen by 4-H members in the Manitou Road area. James Whitmore Jr. (right) seen here on a 1949 senior class trip to New York City with Jerome "Bud" Avery and Janet Slater, tragically lost his life the next year in Korea, an event that saddened the community.

The 1845 Edwin Davis house on 320 Frisbee Hill is one of the Greece area's handsome cobblestone buildings, created using rounded lake stones embedded in cement. Frisbee Hill Road runs around the south end of Braddock Bay and connects to East Manitou Road, which leads to the community now known as Braddock Heights. Until the building of the Lake Ontario Parkway, it was rather isolated after the trolley stopped running, but the spirit of camaraderie among the residents in its modest, well-kept homes, seemed to grow even stronger.

The Northwood School was built on Oscar Litchenfels's farm on North Greece Road and provided classes within the Hilton Central School system for some children from Parma and many from Greece. It was the second octagonal school built in New York State, with octagonal wings patterned after a Liverpool, New York school. After centralization in 1949, Hilton's West Avenue School became the high school for many Greece and Parma students. Greece had no high school of its own at that time and sent children to Charlotte, John Marshall, and Hilton schools.

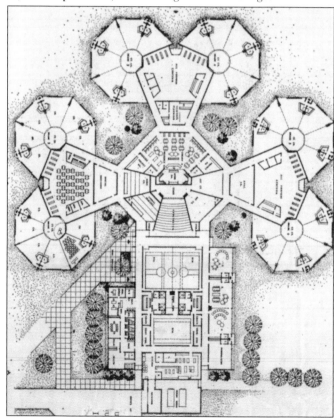

This is an early view of Manitou Beach. Ontario Boulevard still runs along the brink of a high bank overlooking Lake Ontario, with the prestigious name Braddock Boulevard on one short street and the unpretentious names Second and Third on other streets. The small lakeside community's prestigious homes of the past and luxurious homes of the present nestle together in what seems to be a little world apart from the ordinary.

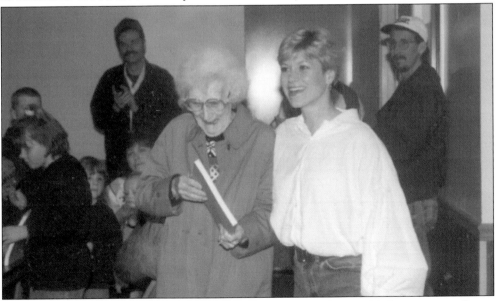

Kathy Turner, Monroe's Olympic speed skating champion, was living with her parents at Payne Beach when she entered international competition. In 1992, she received the gold medal in the 500-meter women's speed skating competition and the silver medal in the 3,000-meter relay. She brought back a gold medal from the 500-meter race and a bronze from the 3,000-meter relay 1994. In this memorable picture taken by the Village Photographer of Hilton, Turner is presenting a special award to Jessie Napier, 92, the oldest cake baker at Hilton's 1996 naming centennial observance. Payne Beach was known as Lotz Point until 1890, following the local custom of naming localities for local landowners.

Two

SIX MILES
ALONG THE RIDGE

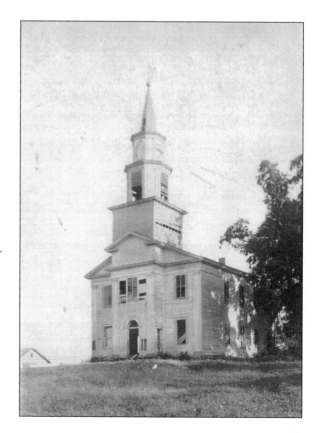

Half in Parma, half in Greece, and bisected by Manitou Road, West Greece was locally known as "Hoosick," since many of its early families came from the Hoosick Falls, New York, area. Jonathan Sheldon built a stately two-story, 50- by 40- by 26-foot Congregational church facing Ridge Road in 1824–1825. The church cemetery was located behind it. After the church closed and became dilapidated, the town boards of Parma and Greece met in an adjacent hotel and declared it to be a public nuisance. It was torn down, and a new grade school was later built on the church site.

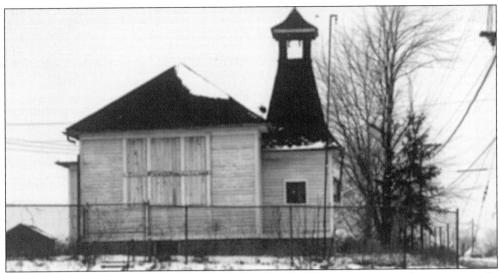

The new Hoosick grade school (above) replaced the former one-room school that eventually became a garage, just across the street from the cemetery. Boylan's general store and post office on the southeast corner of the intersection of Ridge and Manitou Roads at West Greece, across from the new school, attracted customers from Parma, Greece, and Ogden. The proprietor would often welcome you to serve yourself while he basked blissfully in his chair. The store's ledger, now in the Parma historian's office, indicates prices of the past, many years before the store was destroyed by fire in 1974.

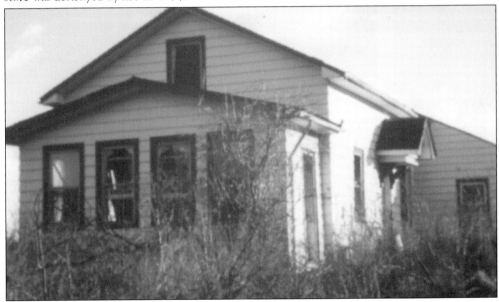

George Harris, a noted authority on Seneca life, was born in Hoosick. Dr. Samuel Beach Bradley was probably Hoosick's most learned resident, serving as a school commissioner and as a state assemblyman. He made his own pills and medicines, read several languages, and, as a hobby, discovered and preserved many examples of flora from Braddock Bay. His house, shown here, was set afire while vacant. Its burned shell was later torn down in order to build a driveway into a neighboring car lot. His little 1825 doctor's office was moved across the road to Parma for use as an outbuilding. Its weathered 175-year-old roof collapsed in 2000.

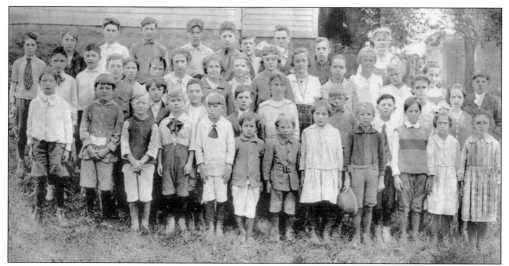

This undated class picture was taken at the Hoosick School on the southwest corner of Manitou and Ridge Roads. Behind the schoolhouse site is the West Ridge Cemetery, where pioneers and veterans from the French and Indian War and the American Revolution are buried. Sometimes called "Boot Hill," it is the oldest cemetery on Ridge Road in Monroe County. Some grave sites were destroyed when part of the hill was removed in order to straighten out Manitou Road.

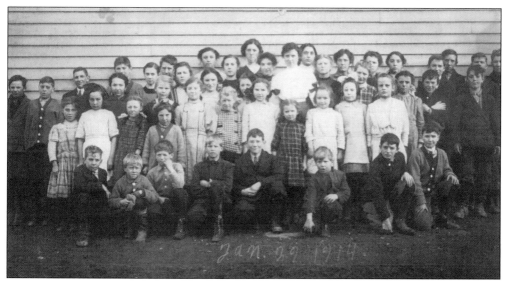

These students attended the grade school in 1914. Some Hoosick students went on to Spencerport High School for advanced education. Until the mid-20th century, very few had the advantages of a college education.

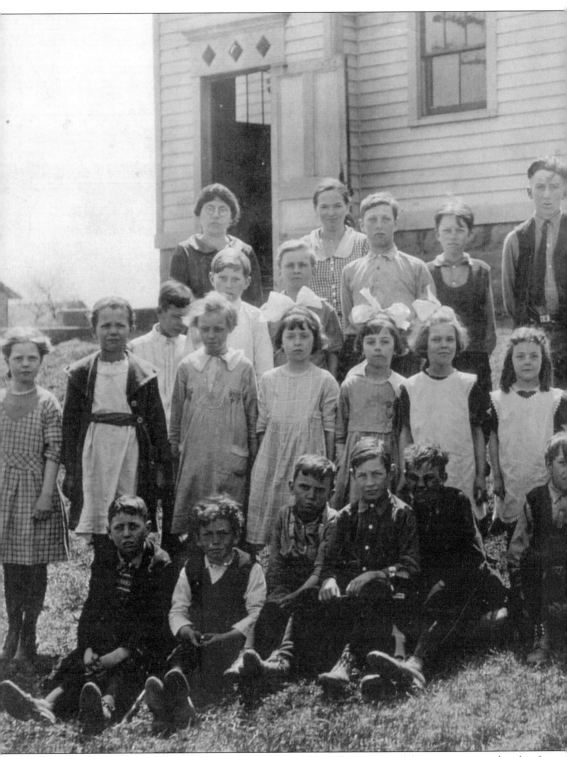

In this 1925 picture of the students and teachers at Hoosick, a corner of the one-room grade school can be seen across the street to the left. Notice the varied hairstyles. In 1956, the abandoned school

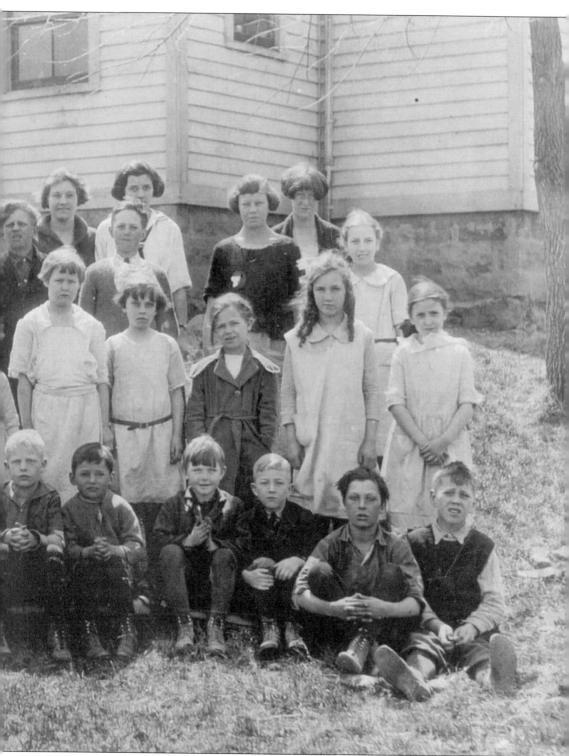

building was moved to Dean Road and converted into apartments. The State of New York later appropriated the land along with a strip west of the cemetery for highway purposes.

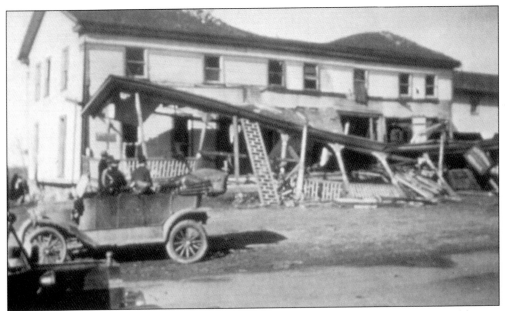

In March 1916, a great tragedy occurred in Hoosick when an acetylene gas explosion blew up the Manchester Hotel. A skating party from Rochester was scheduled to arrive there for a ball later the same day. Although seriously damaged, the hotel was rebuilt and stayed in business, later becoming a rooming house before its demolition in the mid-20th century. It was located on the northeast corner of Manitou and Ridge Roads.

Several cooper shops in the Hoosick area produced barrels. This badly deteriorated tintype shows two unidentified workers at a Hoosick cooperage. They are holding the circular forms that form the shape of the barrels as they are being built.

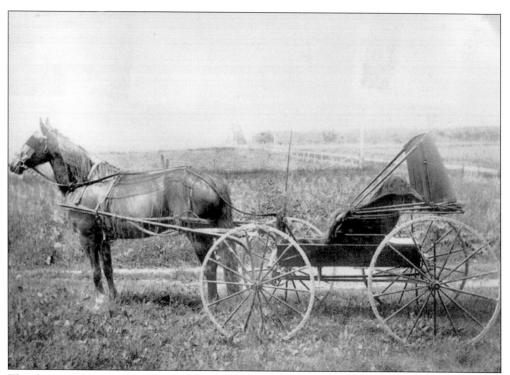

The dirt road behind the William Wilcox family buggy is probably Manitou Road.

Emma Wilcox and her mother pose in front of the Wilcox home on Manitou Road in West Greece.

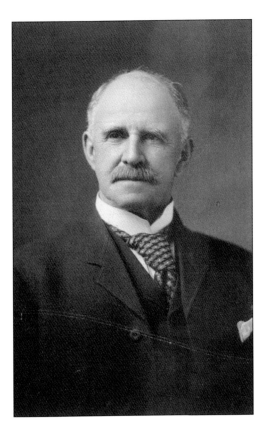

A.P. Beebe, living on the Parma side of Manitou Road, became a supervisor of Parma and headed the committee responsible for building the courthouse at 39 Main Street West, now the Gordon A. Howe County Office Building.

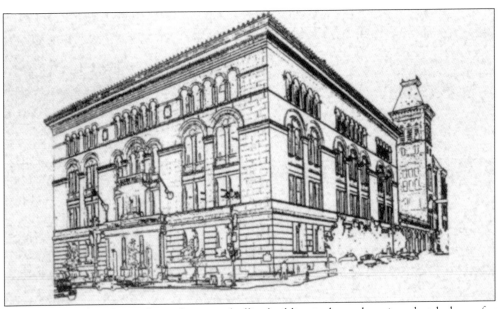

The majestic Italian Revival courthouse and office building is shown here in a sketch drawn for its centennial anniversary in 1995. It is one of Rochester's most impressive buildings.

A.P. Beebe is shown in his later years.

The Beebe house at Hoosick is a beautiful Greek Revival residence. The Lemcke family lived nearby on the south end of Manitou Road in the West Greece area. Richard "Rick" Lemcke became supervisor of the town of Parma and, with his brother Mike, founded R.M. Landscape Industries Inc. It is now one of the state's foremost landscaping firms and frequently wins awards for floral displays at the spring flower show in Henrietta's Dome Arena, where Mike Lemcke chaired the millennial exhibit. It is considered one of the ten best flower shows in the nation. The creative landscaping talents of the firm can also be seen and enjoyed at Wegmans market sites.

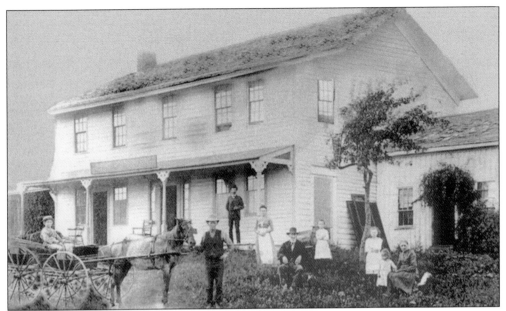

Edward "Teddy" Cox was the proprietor of one of the two hotels at Hoosick when this picture was taken. His son Leon, who later built the Dutch Mill at Barnard's, had recently been born, and family members who had come to see the new baby happily posed for this family picture in 1887. William Cox, an 1823 Parma pioneer, is the elderly gentleman with whiskers seated in the center. To the right of William are Vina Maud Cox (Munger); Grace Cox (Cross); Elfie Anna Cox (Burger); and William's wife, Mary "Patty" Johnson. Francis Cox is in the buggy. Teddy is holding the horse. Teddy's brother William is standing on the porch behind his wife, Carrie Whittier Cox. The Cox hotel was once known as the Arlington, a name it had while operated by Thomas Streb.

Missing from the picture above are Ward Cox, seen here, his brother Leon, and their mother, Martha. Ward was the father of the author-historians Shirley Cox Husted and Leith Cox Wright. His grandson, Norman Wright, an expert on railroads and stamps, is also the author of several books. Through Edward's wife, Martha Whittier, and William's wife, Carrie Whittier, the family is distantly related to the poet and journalist John Greenleaf Whittier. Both Norman and Shirley became active journalists. Leon Cox's granddaughter, Carol Gursslin, is a published children's author.

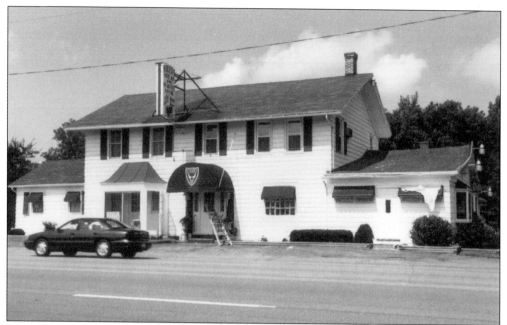

Teddy Cox was an avid drum player. Other Cox descendants showed musical talent, including Loren "Sammy" Cox, whose talent on the saxophone was legendary, and organist Bill Burger, who had his own band and played at the Wautoma Beach dance hall, Streb's, the Lyon's Den, and other restaurants. After several subsequent owners and name changes, the Arlington is now called Streb's. Remodeling has only slightly changed the appearance of this hotel, which is located on Ridge Road and is the oldest hotel in Greece.

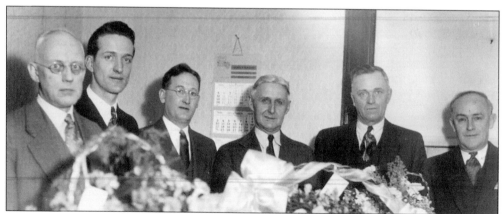

Two of Edward Cox's sons, Ward and Leon, became keenly interested in politics. Lee Cox became a Greece councilman, a charter member of the Barnard Fire Department, and proprietor of the Dutch Mill restaurant. This picture was taken in 1934, when Greece became a first-class town (the highest possible governmental jurisdiction, partly based upon population). The town officials shown here are, from left to right, Wilbur C. Deming, Supervisor Gordon Howe, Andrew J. Schell, Clifford E. Clarke, Harold M. Veness, and Leon Cox.

Lee Cox's sons, Eddie and Ray, began the Greece Taxi Service. With son-in-law William Graham, they operated Cox Construction Company. Lee Cox's son Eddie, for 21 years a noted racecar driver, held the title of New York State champion. He and Raymond later operated the Welcome Ranch Restaurant and Motel on Ridge Road.

The Hooper house, later known as the Cat Nap, is a cobblestone landmark at 4350 Ridge Road West near Hoosick. It was once the residence of Margot Graham, whose radio show featured her breezy commentaries and extravagant piano artistry. This photograph appears courtesy of the Greece Historian Office.

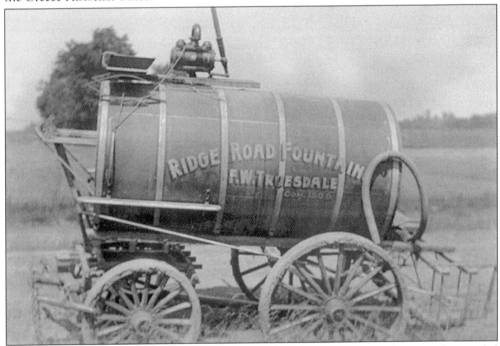

Frank Truesdale operated the Ridge Road Fountain, offering services to farmers who needed their fruit orchards sprayed. Rigs like this one were also used for spraying water to control dust on dirt roads or for cleaning and preserving paved roads. Native American skeletons were unearthed on Samuel Truesdale's farm near Ridgeway Avenue when highway construction was underway in 1878. Frank Truesdale worked as a Greece supervisor from 1904 to 1909.

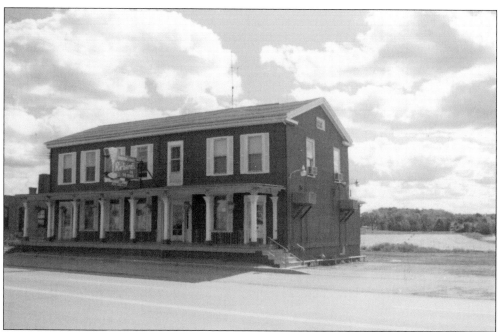

William Fall's old tavern on the north side of Ridge Road was a stagecoach stop located on the site where St. John the Evangelist Church's 1875 cut stone sanctuary was later built. Eventually, the inn was moved across the street and became known as Buckert's, then as Richard's-on-the-Ridge. Land cleared for the modern shopping mall now behind the tavern site can be seen behind the hotel in this photograph from the Greece Historian Office. Across the street, Asa Rowe's 1826 nurseries, once the county's first commercial nurseries, are long gone.

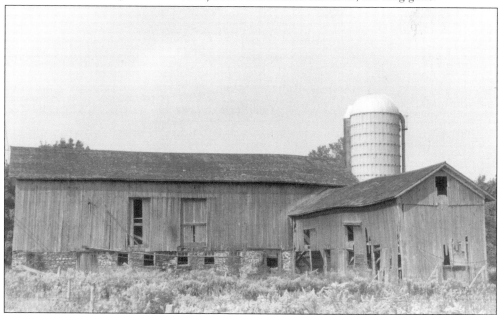

Denny Wright's photograph of John Haslip's aging barn on Manitou Beach Road near the Bridges is a poignant reminder of the gradual decline of the farming industry in Greece after housing tracts covered the land. The value of properties along Ridge Road skyrocketed.

49

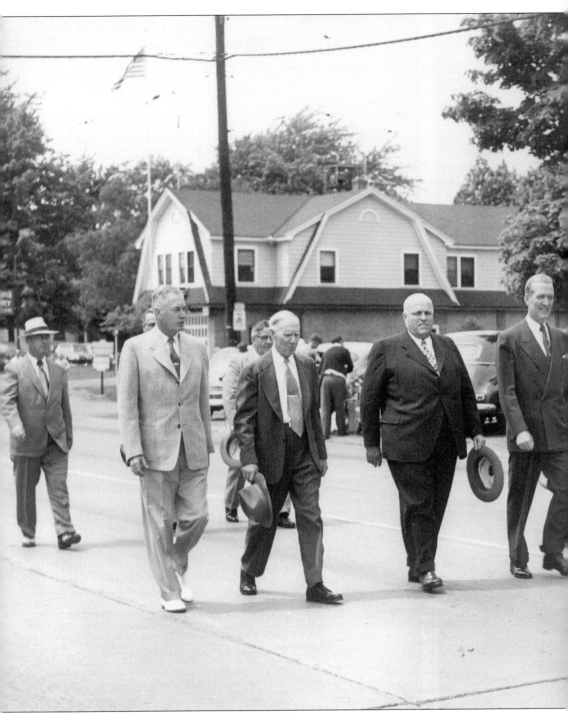

The fire station at Ada was located next to Buckman's ice-cream store. A glimpse of the Greece Baptist Church can also be seen in this Memorial Day parade picture preserved by the Greece Historian Office. The church stood on the northeast corner of Ridge and Long Pond Roads from 1834 to 1962. After a more modern church was built to the north, a Mobile gas station replaced the church where the Reverend Fred E. Dean was a beloved pastor for many years.

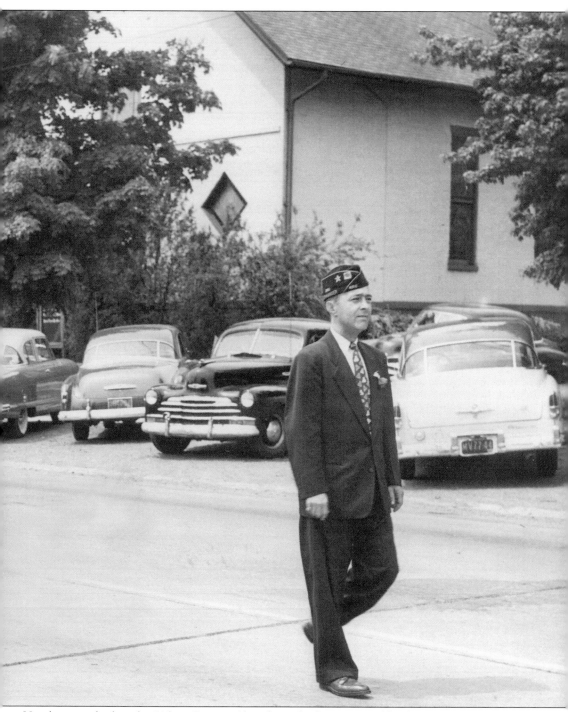

He also preached at the Hilton Baptist Church in the later years of his long career. Ada was the name given to the community's post office, c. 1900, in order to honor postmaster William H. Anderson's former home in Ada, Michigan. More often, however, the crossroads area was simply called Greece.

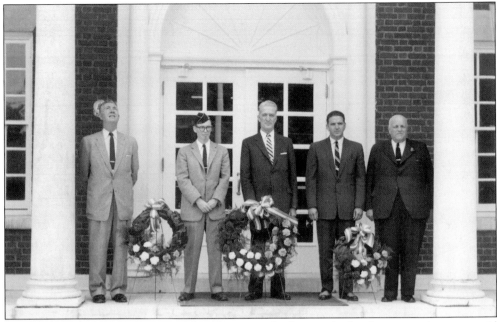

Federal funds for the construction of roads, sewers, bridges, and schools were an important aid to the economy during the Great Depression. Greece Town Hall was one of the many projects supervised by Gordon A. Howe. When it was erected in 1919, it rapidly became the pride of the town. This picture from the Greece Historian Office shows a 1957 Memorial Day flag ceremony in front of the town hall.

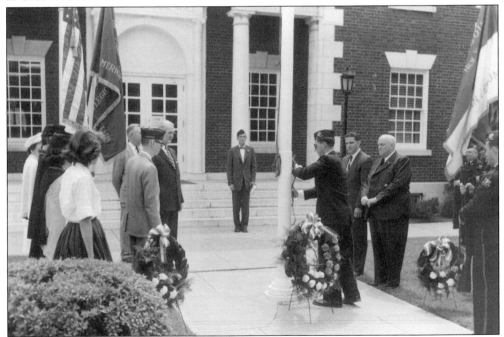

The dignitaries participating in the ceremony included Frank McCone, William Easton, Gordon Howe, Vincent Tofany, and Sheriff Albert Skinner. This view of the ceremony also comes from the Howe collection in the Greece Historian Office.

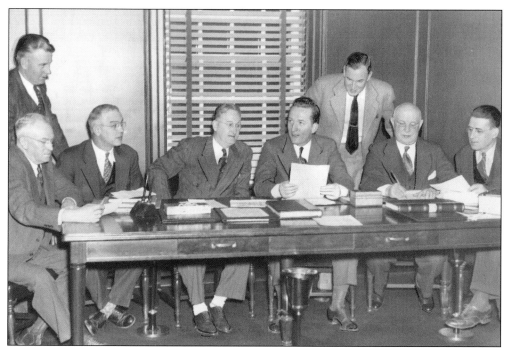

Members of the Greece Town Board in 1946 are, from left to right, as follows: Harold Veness, councilman; Emmett Cooper, highway superintendent (standing); Arthur Koerner, councilman; Andrew Schell, councilman; Gordon Howe, supervisor; William G. Easton Sr., town attorney (standing); Hugh Hughes, clerk; and Ray Defendorf, councilman.

This envelope from the town clerk's office proudly features the town hall entrance, printed in pastel blue as a town logo. The building's demolition in 1999 (by which time it had seriously deteriorated) is still regretted by those who appreciated its Dutch Colonial style. For the public, it had become the best-known symbol of the town of Greece.

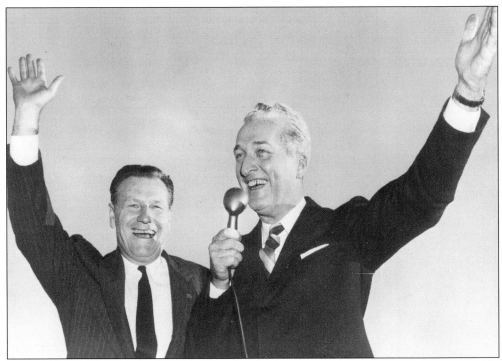

Gordon Howe's rise to political prominence began when he first won election in 1934 by promising to work full time as supervisor, a service not offered by previous supervisors. After serving on the board of supervisors for 12 years as chairman, he became the county's second county manager in 1960. He remained in office until 1971, retiring after 42 years in government. During that time, he enjoyed a close association with many Republicans.

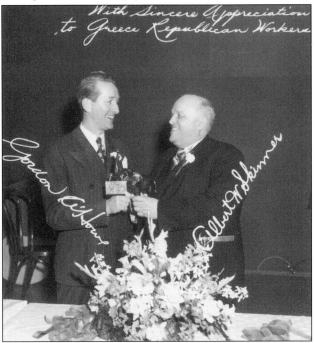

A "thank you" photograph autographed by both Albert Skinner and Gordon Howe was sent to campaign workers. One is now in the Greece Historian Office collection. Howe considered the sheriff to be his best friend. They went almost everywhere together, giving rise to speculation as to which one was really "Mr. Republican," the head boss of the county. Howe believed that he was the top man, but Skinner never revealed his opinion. The truth was that they were an excellent team, working closely together for nearly four decades.

Counting votes at the Greece Town Hall was an election night tradition. Sheriff Skinner, a quiet bachelor, would often forget the names of women, but he would just called them "Missus." Here, in a rare situation, Bob Gapsky's camera recorded a special moment as Skinner accepted an enthusiastic congratulatory kiss from Barbara Harnden on primary night in 1970. A simple handshake was the sheriff's customary greeting, while the ever gracious Howe did the kissing. At left is Vincent Tofany (later the state's motor vehicle department head) and Gordon Howe.

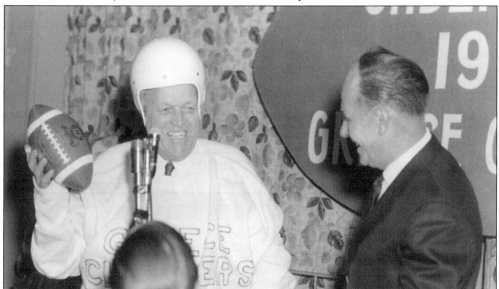

Although seemingly austere, Skinner was a good sport who would do almost anything asked of him. He appeared dressed as a woman dancer in a Grange skit and played the cymbals at a performance of the War of 1812 Overture at the Rochester War Memorial while fireworks went off overhead. Here, he is dressed as a Greece Charger, greatly amusing local newscaster Warren Doremus. This picture comes from the Greece Historian Office.

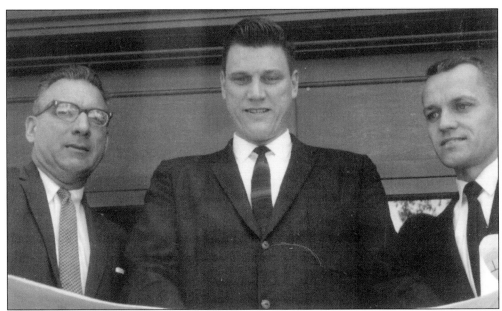

William Steinfeldt, the popular state assemblyman from Charlotte, and his wife, Dorothy, were very active in politics, senior citizens activities, and veterans programs. After County Historian Florence Lee recommended the creation of a Monroe County flag, Steinfeldt arranged for a local woman to make the first flag; he proudly watched as the Shoreliners carried it in a parade where it was shown for the first time. Here, Steinfeldt, county legislator John Hoff and Roy Kanous are shown at a political event in Parma. The Robach family, father and son, have also been very prominent in state politics. A section of local expressway has been named in honor of Roger J. Robach. Robach Landing at Henpeck also bears the Robach name.

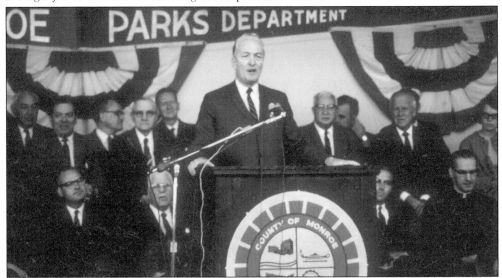

Howe and many public officials participate in a 1966 ceremony at the County of Monroe Parks Department bandstand. Howe personally paid for the war bond awarded to the designer of a new county emblem featuring a gear surrounding symbolic designs representing government, education, agriculture, and industry. Although county executives have since chosen two other emblems for county logos, the Howe emblem remains on the county flag.

Howe (center) is seen with Kenneth Courtney (left) and Vincent Tofany. Howe was famous for his customary hearty banquet greeting welcoming everyone to the "Golden Shores of Lake Ontario." He adopted that phrase for the local area after seeing a real estate sign in Florida advertising a Golden Shores subdivision. Less flamboyant, but highly respected was a successor, Supervisor George Badgerow.

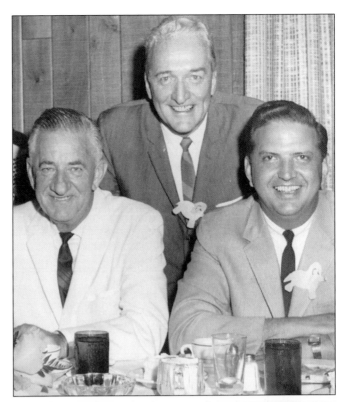

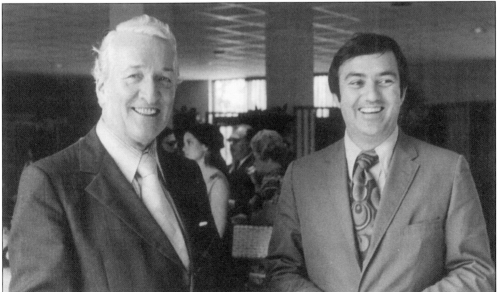

Another supervisor, Fred Eckert, is seen here with Howe at an open house for the Park Ridge Nursing Home in July 1972. Eckert later became a state senator and then an ambassador to the Fiji Islands. Vice Pres. Nelson Rockefeller attended the dedication of the new Park Ridge Hospital in 1975. A professional building and other facilities also occupy the campus of Park Ridge, once the Wagner farm. The farm cemetery burials were moved to Fall's Cemetery in 1967, but the attractive, cut-stone Wagner home still remains as part of the complex.

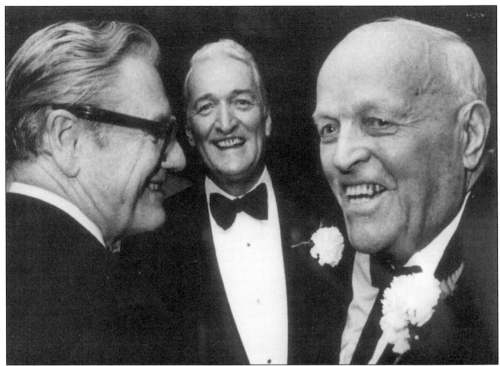

Gov. Nelson Rockefeller (left), Gordon Howe, and Sheriff Albert Skinner share a happy moment at a formal dinner gathering.

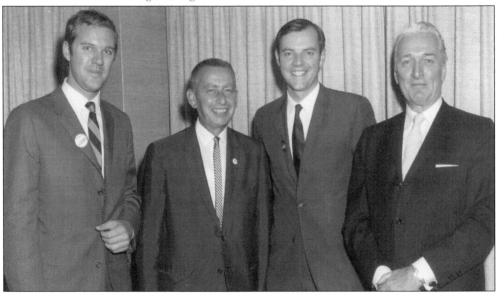

Gordon Howe with his sons, Gordon Jr. (left) and David (third from left), greet Governor Wilson in 1972. The family was often involved in politics, and Gordon Jr. unsuccessfully ran for a state office. Gordon Howe Sr. was briefly considered for a state comptroller candidate, but never deeply yearned to serve beyond the County of Monroe. His daughter, Gretchen, became the Monroe County treasurer. Supervisor Donald Riley and his parents also became prominent public servants.

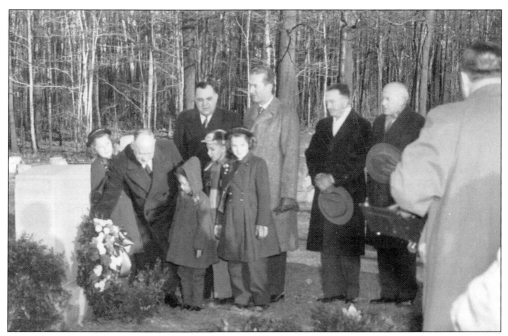

Mayor Samuel Dicker, New York Sen. Frank E. VanLare, Gordon Howe, other politicians, and several grandchildren were among those participating in this graveside ceremony honoring Thomas Broderick, a longtime party leader from Irondequoit.

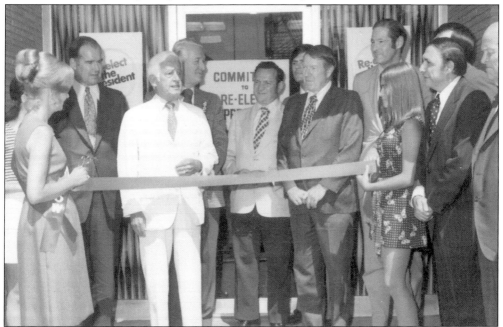

Many politicians were present for the ribbon cutting of president Richard M. Nixon's campaign headquarters in 1972. From left to right, they are as follows: Rep. Barber B. Conable Jr.; Sen. Kenneth Keating; Gordon Howe; Jack Lazarus, the county's popular district attorney whose large family always aided his campaigns; two unidentified gentlemen, Rochester Mayor Steven May; county legislature Pres. Joseph N. Ferrari; and Sheriff Skinner.

E. Sturm's Pine Tree Inn on Ridge Road West at Eddy Road (now Mount Read Boulevard) appears on a postcard preserved in the Greece Historian Office.

This sweeping view of old Ridge Road, leading west past the Pine Tree Inn, is another gem kept in the Greece Historian Office.

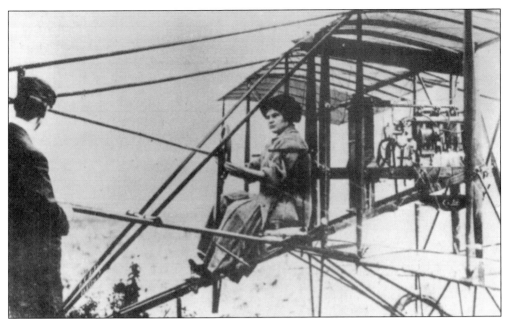

On Eddy Road in the days when it was still a two-lane road leading through desolate wilderness areas, little Blanche Stuart Scott was born. She became the first woman to fly solo in 1910, and the first to drive an automobile coast to coast. She pursued a career as a test pilot and flew exhibition flights until several friends were killed in plane crashes. A later crash so affected her that she ended her flying career.

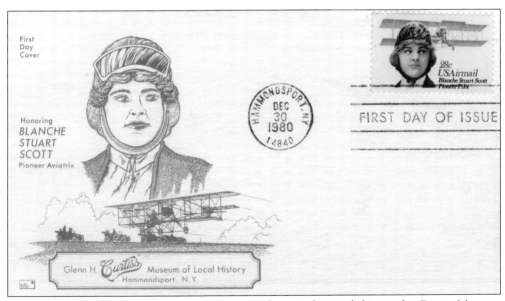

Shown here is a 1980 first-day cover at Hammondsport, where exhibits at the Curtiss Museum pay tribute to Blanche Stuart Scott's historic achievements. In the 1940s, she became known as the lively radio personality "Roberta."

This aerial postcard view shows Kodak Park surrounded by the homes of its workers. George Eastman established a film manufacturing plant in Greece on the site of Donnelly Nurseries, thus the name "Park." Eastman Kodak Company's film and camera plants once employed more than 90,000 workers in the days before digital photography. Aerial photography, a Kodak specialty, became an integral part of space exploration. Now greatly downsized, Kodak is still the county's largest employer, followed by Wegmans Enterprises.

Hanford Landing Road still runs through Kodak, continuing on down the river dugway to

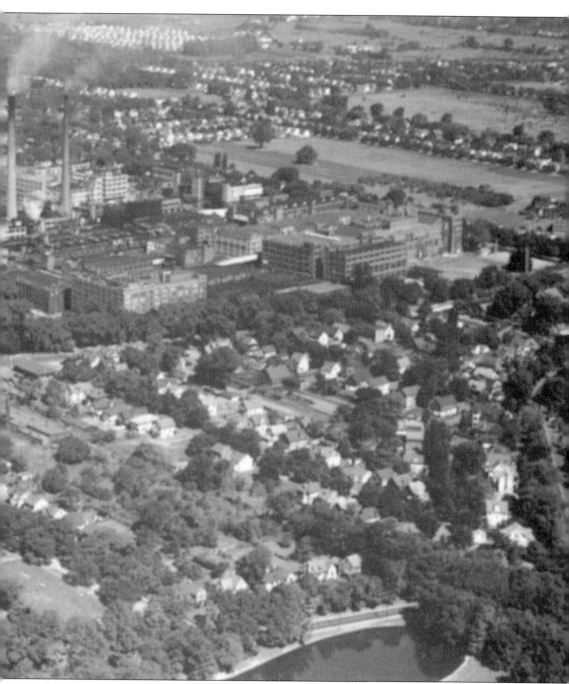

Kodak's sewage treatment plant on King's Landing. As members of the pioneering King family passed away, they were laid to rest in the little cemetery on the riverbank above the landing, Rochester's first cemetery. When the dreaded Genesee Fever continued to plague the area, most settlers left. The Eastman Kodak buildings now surround the cemetery. Not far away in front of his Kodak Park plant is the grave of George Eastman, the company's founder. The city that the pioneers dreamed about has become a thriving reality, thanks to Kodak.

Eastman Kodak Company's brownies were a beloved advertising feature. Here is an enchanting advertisement featuring the whimsical elves.

A Kodak model poses in the Harradine orchards near Manitou Road for this wonderful apple blossom time picture, used in the Kodak "picturama" at Grand Central Station in New York City.

Because of Kodak, amateur photographers were soon preserving memories of their family life and their travels. This orchard scene comes from the large collection of the Mitchell family, now in the Parma historian's office.

Bonesteel Street runs over the farm once owned by Henry Bonesteel. His daughter, Jessie, was born there in 1849, exhibiting a rare elocutionary ability by the age of ten. She became a nationally known actress and producer, changing her stage name to Jessica Bonestell.

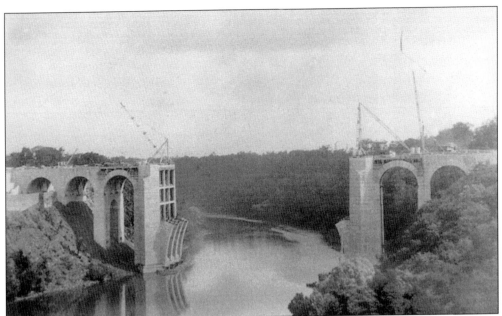

At what used to be called "the End of the Ridge" before a bridge spanned the chasm, the Veterans' Memorial Bridge, built in 1931, is an important structure linking the Kodak area to Irondequoit and the city of Rochester. It spurred the development of housing tracts in neighboring areas. A prehistoric palisaded Native American village once existed in what is now Maplewood Park. Flint deposits near the Seneca Parkway were used to make arrowheads.

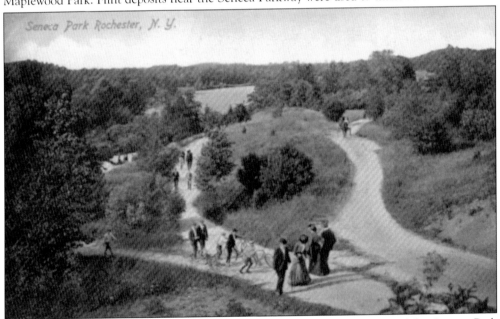

Seneca Park Rochester, N. Y.

Another Native American site was found in Seneca Park, later the home of the Seneca Park Zoo, a public pool, picnic pavilions, Trout Pond, and river trails. Kodak workers now use the Waldo Nielson pedestrian bridge to cross the river and spend their lunch hours in the scenic park. Along the river from Driving Park Bridge to Charlotte and by the ponds and lakeshore, several other Native American campsites were found.

Three

THE COUNTRY ROADS LEAD HOME

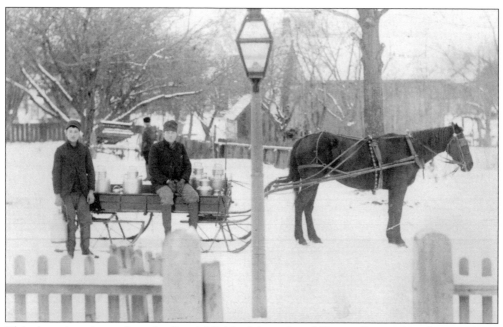

This charming picture from the Rundel Public Library Local History Division's collection shows a Latta Road milk delivery, c. 1860. Once a Latta Road mansion, Arthur Yates's splendid house sits unused and deteriorating near Greenleaf Road. Ice was harvested in the winter from a scenic pond dug on the farm. The Joseph Fleming house, a Latta Road landmark nearby, recalls memories of the several Fleming families who pioneered the area. The large Irish colony located in the northeast corner of Greece gave 343-foot-high Mount Read its nickname "Paddy Hill."

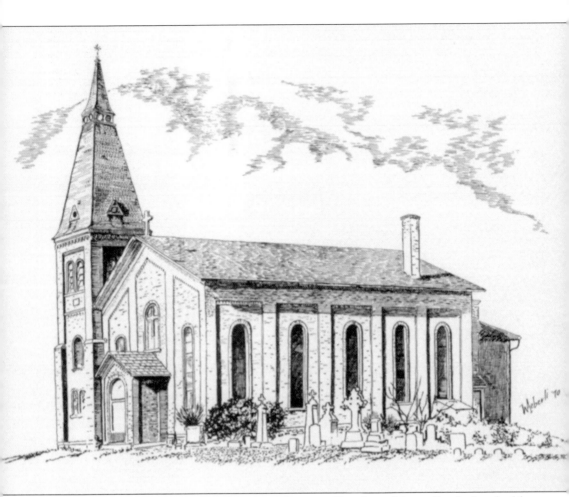

Beside the 1858 Our Mother of the Seven Sorrows Church on Mount Read, sketched here by Greece artist William Aeberli, can be found the grave sites of early Irish families and of Fr. Louis Jean Maurice, the French priest who founded the church at the corner of Latta Road and Mount Read Boulevard. Some believe that Father Maurice's spirit still watches over his church and that he still can be heard walking overhead each evening, near the bell tower where he so often went to ring the church bell. Father Maurice also founded the Holy Cross Church in 1863 and St. John the Evangelist Church in 1865. He died December 25, 1895.

Squire Nicholas Read was an 1823 pioneer, active in politics and church affairs. Mount Read Boulevard and Mount Read itself bears his name, although residents sometimes called it "Mary's Hill" because the church there was named in honor of the Virgin Mary. Her statue, placed in a high niche in 1878, was a familiar local landmark. The hill was then steep and hard to climb. When a fence north of the church needed to be moved in order to improve the road, 140 men showed up to help the squire move the fence. They picked it up and moved it in unison without disturbing a picket. The Rigney-Feeney house is a landmark on Latta Road near Paddy Hill.

Located south of the church, McGuire Road honors Patrick McGuire, an early church leader and church founder. Earlier, it was called the Indian Fields Road because a cultivated area there was thought to have been used by Native Americans before the Irish came.

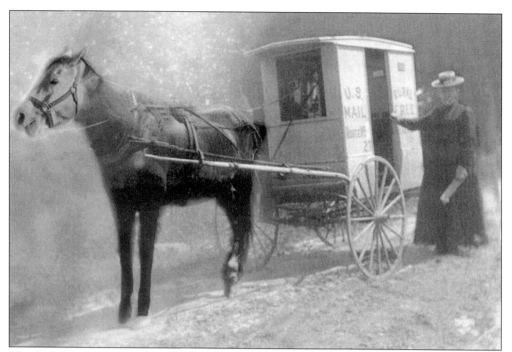

The little North Greece Post Office was moved to Manitou Road, where it became a storage barn after the new post office was built. Other remnants of an earlier post office, perhaps the Mount Read post office, are still in a home near Paddy Hill. This mail cart made deliveries around the area.

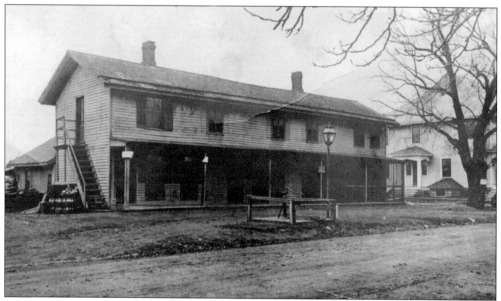

The Domino Inn at North Greece was built by James Fleming in 1909 with many rooms to handle the large crowds expected because of a nearby railroad station. The crowds never materialized, the station was burned down, and the Hojack tracks were removed, but the building still survives. Larkin's Hotel, shown above in a Greece Historian Office photograph, occupied part of the site.

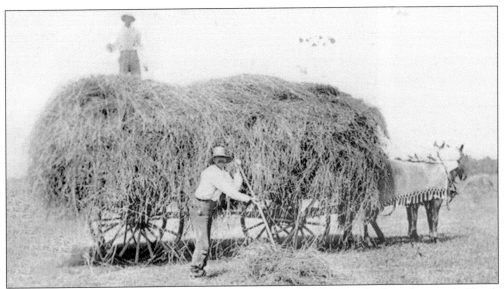

Workers on the Kirchgessner farm make hay. The family lived near College Avenue in North Greece and later on the Hilton-Parma Road. The farmer may be Bill Herbstsommer (1858–1945), who later became a plumber in the Hilton area.

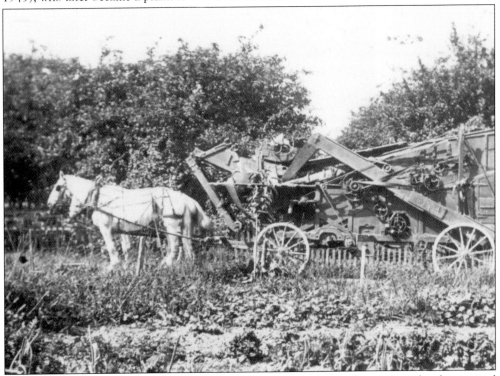

A hand-fed threshing machine like this one, shown beside the Kirchgessner orchards, required a crew of farm laborers to place heavy shocks of grain into it. Others bagged the kernels that were shaken out of the stalks. A year's crop would be ruined by mildew if it rained on the shocks while they lay in piles waiting to be threshed, so speed and good weather were necessary at harvest time.

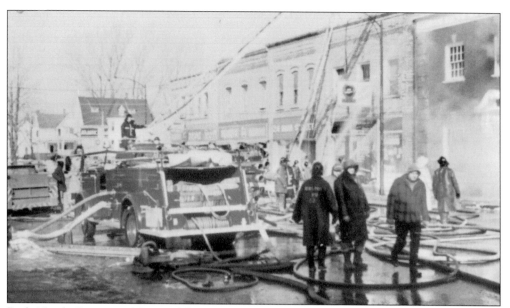

Both North Greece and Barnard firemen assisted with the battle to contain the tragic fire at Hilton on March 21, 1965. Mutual assistance often involves several neighboring departments, but this was the county's first test of its mutual aid program. It was the costliest fire to date within Monroe County, destroying over $1 million worth of property as it burned out the heart of Main Street and ruined several Hovey Street homes.

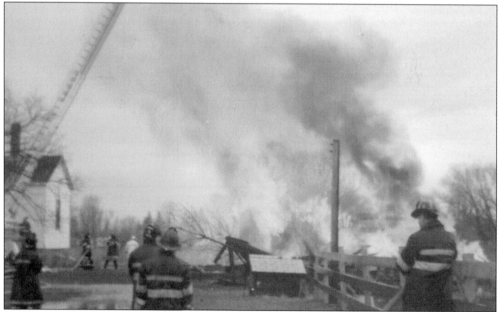

The house was saved, but the barn was destroyed when North Greece firemen battled this accidental fire on Ann and Alden "Gil" Barons's farm on Parma Center Road. Ann Barons was the first manager of the State Bank of Hilton's branch at Antelli's North Greece plaza. The North Greece Fire District extends into the eastern portion of Parma, and the Greece ambulance crew and police frequently aid the area. For years, Parma's east side was also part of the area encompassed within the North Greece post office district.

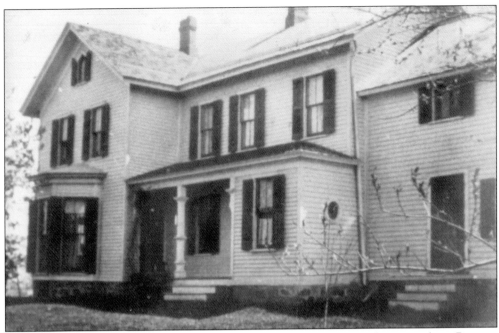

There is more than one way to save a house, as the pictures on the next few pages show. Because Wegmans Enterprises decided to save the attractive farmhouse on Greece Center's southwest corner, the Larkin-Beattie-Howe House at 3177 Latta Road acquired a new career as the historic building that now houses the Greece Historical Society's history center and museum. The corner site became the location for a splendid Wegmans plaza. This image was graciously provided by the Greece Historian Office.

The Howe family lived from 1941 to 1964 in the Civil War–era house that Wegmans donated to the Greece Historical Society. Posing under a picturesque arch are, from left to right, Gretchen, Lois, David (standing), Gordon Jr., and Gordon Howe Sr. The family would stand on the second step of the stairway each Christmas while, through the archway, Gordon Sr. directed them in the singing of Christmas carols. Some prominent guests were entertained there. The Greece Historian Office provided this picture.

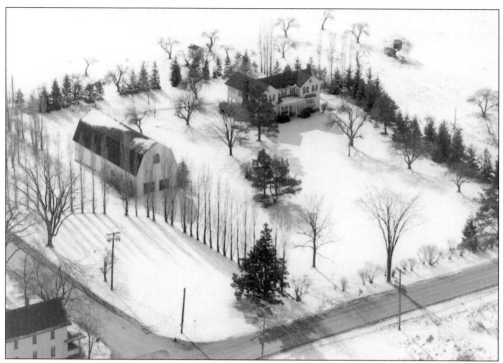

It is believed that this house once stood closer to Latta Road, but was moved back because of the noises and discourteous actions of patrons of the nearby Catarack House hotel or Peter Larkin's American Hotel at Greece Center. The American Hotel burned down in 1893. The long line of Lombardy poplars that Howe personally planted along Long Pond Road are now gone too, but are still evident in this aerial view from the Greece Historian Office.

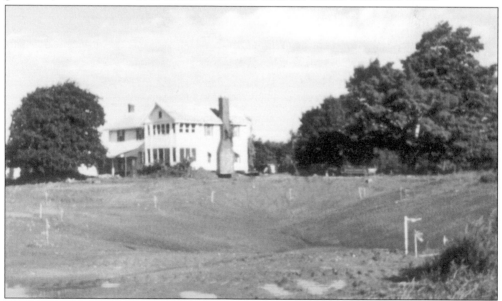

A giant tree in which the Howe children once played and other large trees on the property were removed, ponds were created, and the entire site was beautifully relandscaped by R.M. Landscape Industries Inc. The flowering trees lining plaza entrances are breathtaking in the spring.

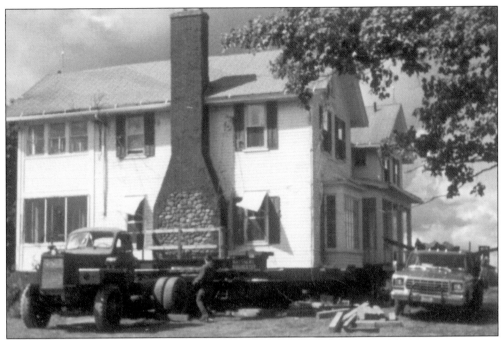

This picture of the house-moving project conducted by the F.O. Matthews house-moving crew shows the structure jacked up and ready to leave its Latta site in September 1988.

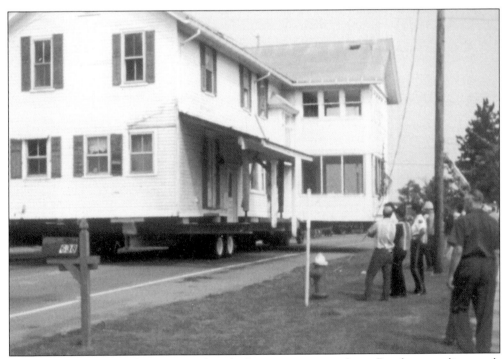

A small crowd of eager observers watches the house move across Latta Road, proceeding north to its new location at 595 Long Pond Road. Many carried small American flags. A larger flag adorned the truck.

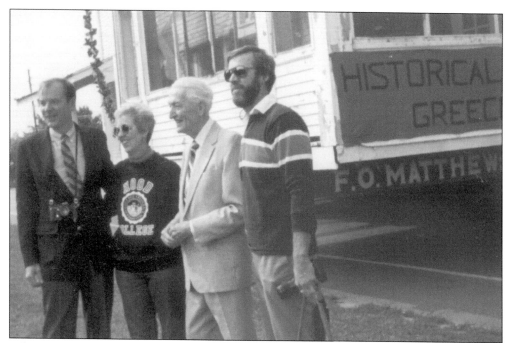

All the Howe family marched beside the house, waving to applauding bystanders as the house made its slow journey north down Long Pond Road. From left to right are Gordon Jr., Gretchen, Gordon Sr., and David Howe.

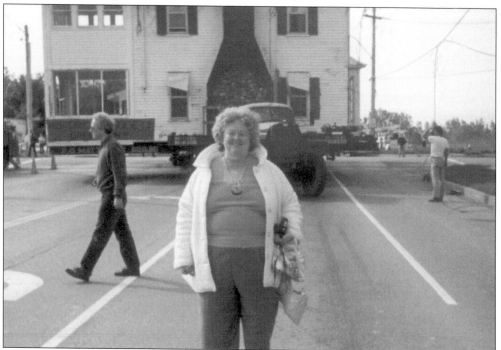

County Historian Shirley Husted was among the photographers recording the historic journey and took the pictures reproduced here. A local television station later broadcasted the entire moving process.

The peanut gallery watches in fascination as the house nears its destination. The new Greece Town Hall, later built next-door, has a cupola resembling the old Charlotte Lighthouse and a new memorial to all local veterans. The cupola from the old town hall originally built to honor Greece veterans was salvaged by Lorraine Beane of the Greece Historical Society and is now behind the museum.

Kay Pollock, a former president of the historical society, rushes to greet the Howes and the movers as they proudly pose beside the relocated house. Ever the politician, Howe was still waving. As the house sat on its new site, Gretchen Howe and historical society members enjoyed a quiet moment on the porch after the crowd left. The family returned to hold a private gathering at the house when Gordon Sr. died and poignantly recalled their happier days there.

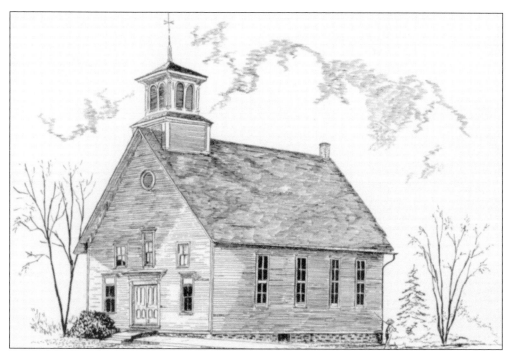

Greece artist William Aeberli sketched the Maiden Lane Methodist Church, erected *c.* 1874. The street was supposedly so named because a large number of unmarried ladies lived on it. Similar humor was shown in the colloquial names Podunk, Hoosick, Paddy Hill, Henpeck, and the Bridges. More serious are the names given to designate memorials in honor of Gary Beikirch, a Vietnam veteran; Sherwood Park, once owned by Dr. Sherwood Sawyer, a Hilton physician who created Wautoma Beach in the 1920s; Vincent Tofany, supervisor and state commissioner of motor vehicles; and Basil Marella, a longtime town official.

South Greece was the official name for Henpeck, a locality where Elmgrove Road crosses the canal, so called because its male residents protested that they were often "henpecked." This trade card, preserved by the Parma historian's office, shows a really henpecked rooster. The Rhode Island red bantam is a breed developed in Greece by Perrin Johnson of Mill Road. They lay brown eggs considered to be a delicacy.

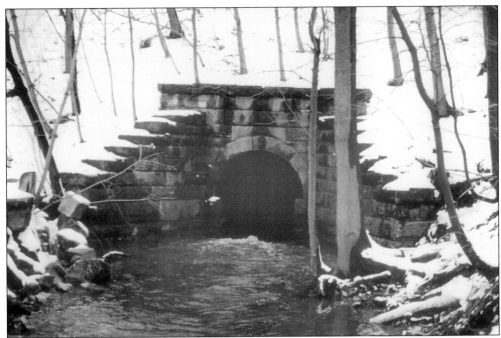

A rebuilt Erie Canal culvert still exists on the former Niles Hawes property on Ridgeway Avenue, near the Henpeck dock. Nearby is a junction lock used while building the enlarged Barge Canal at the area where the old Erie Canal and the newly widened canal for barges met.

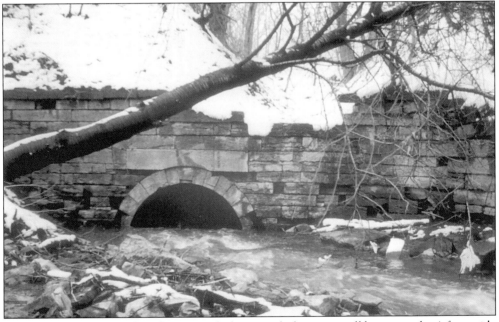

Grace Hawes Cox remembered racing with the animals drawing small barges on the 4-foot-wide canal behind her parents' home before the canal was widened and deepened to accommodate larger boats. The end of the culvert facing Ridgeway Avenue dates from c. 1860; its other end, the original 1823 canal culvert, was built to carry a stream on the Perkins farm underneath the canal.

That amazing new innovation, Polaroid photography, recorded this tender moment at the Ries home on Standish Road in 1961. Elfie "Elf" Anna Cox Burger (left) holds her new granddaughter, Anna Ries, while Grace Cox holds her grandson, Donald Ward Husted. Donald became a graduate of the U.S. Military Academy at West Point in 1983.

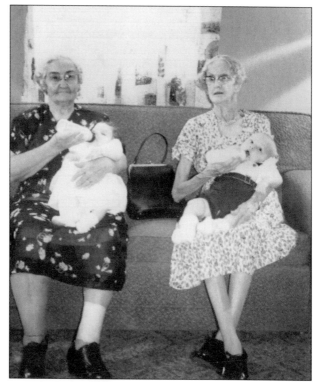

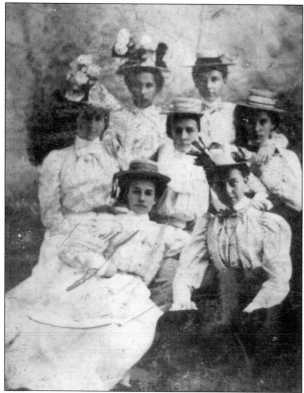

Elf was a gourmet cook whose clam chowder and scrumptious pies prepared for guests at the Dutch Mill dining room helped establish that restaurant's fine reputation. Her sister, Grace Cox Cross, made cakes beautifully decorated with rail fences and other embellishments. One day, Elf slipped on a wet concrete floor in the restaurant's cellar kitchen and injured her leg. It became ulcerated and never healed; for the rest of her life she wore a bandage, and pain was her constant companion. A skilled hat maker, she may have made some of the hats pictured on this old tintype showing family relatives.

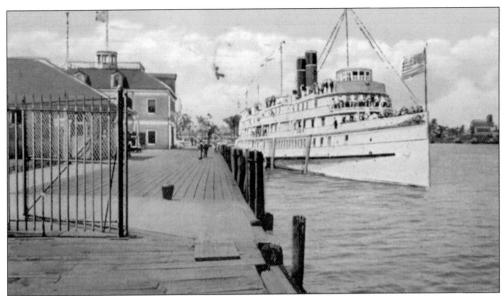

This postcard's harbor view was photographed from Irondequoit near the naval armory and customhouse dock. Thousands of lives have been saved by the U.S. Coast Guard's educational classes and patrols along the western end of the lake. They conducted their operations from both sides of the harbor.

Dewey Avenue was named to honor Adm. Chester A. Dewey, whose fleet destroyed the Spanish fleet on April 25, 1898, at Manilla Bay during the Spanish-American War. Local shipbuilding at Odenbach's plant on Dewey Avenue near the lake assisted the war effort during World War II. This photograph is from the Greece Historian Office.

Stutson Street, by the approach to the bridge across the river, at one time had a street paved with Telford cement cubes. Manufactured at a factory on Ridge Road, just west of North Greece Road, they were used to pave Ridge Road and other main streets, but proved to be impractical, as they soon wore down. This is a Greece Historian Office photograph.

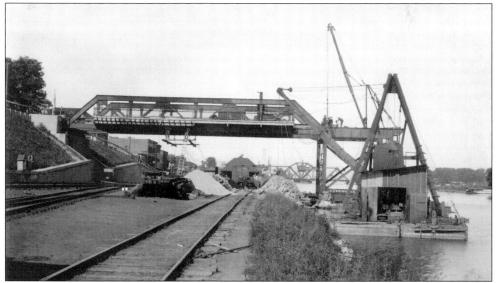

This September 24, 1917 image shows the building of the Stutson Street bridge, one of several spans that have carried vehicles over the water. The east bascule was let down and tested for the first time as this photograph was taken. The old paint factory in Irondequoit, on the east side of the harbor.

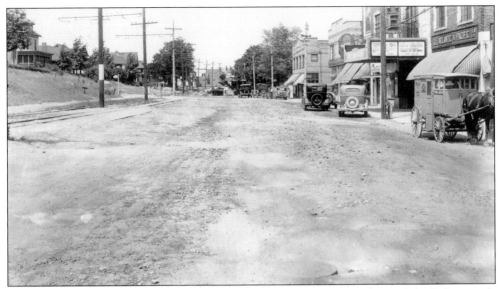

Note the many puddles in the street in this view of Lake Avenue just beyond the Baltimore & Ohio Railroad bridge at Boxart Street. Because construction of a 4,000-foot stormwater and sanitary sewer destroyed the pavement, it received a 12-inch-thick stone base over the sewer and a 6-inch base on either side. Workers topped the 27-foot roadway with a 3-inch bituminous macadam layer in 1937.

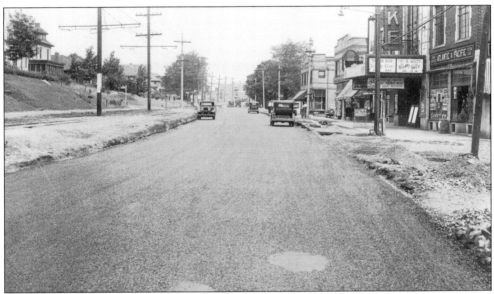

With street work completed, there were only a few puddles and what a reporter described as "excellent shoulders." Ralph Bellamy was staring in the double feature at the Lake Theater that June, and a large sign announced that dishes would be given away to ladies attending on Friday. Charlotte Appliances now occupies the old theater building. The Great Atlantic and Pacific grocery store (A & P) was located next-door, and awnings protected store fronts.

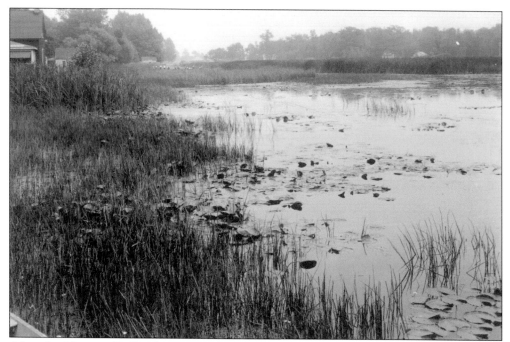

After the Manitou Trolley line stopped running in 1925, several resorts along Lake Ontario were left without easy access. Beach Avenue was extended by the addition of 1.38 miles of bituminous macadam pavement, and a new 100-foot span bridge was erected on timber piles. The site for the new road was a swampy area filled with rushes and water lilies.

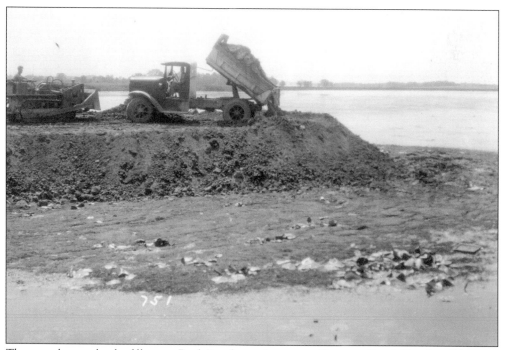

These workers make the fill across Buck Pond near the present Crescent Beach Hotel on Edgemere Drive. The completed road was 20 feet wide with a Telford base of gravel and crushed stone.

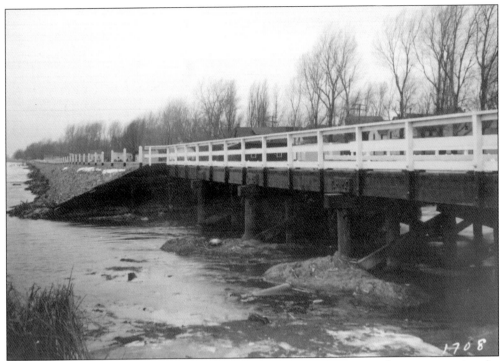

The new bridge rests on creosoted piles. Sheriff Skinner joined sportsmen's groups opposing the filling of the wetlands. They feared danger to wildlife and wanted to continue to hunt ducks in the ponds.

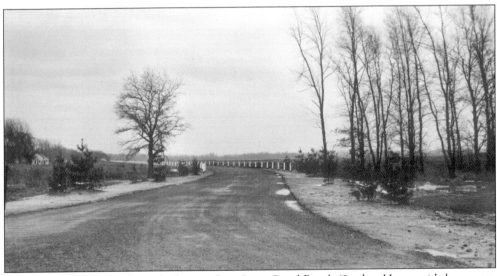

This view of Edgemere Drive looks east from Long Pond Road. Gordon Howe said there were more ducks than ever after the landfills. Since the area is in the North Atlantic Flyway, ducks, geese, and sea gulls continue to migrate from Canada. The new route shortened the commute to Rochester by several miles.

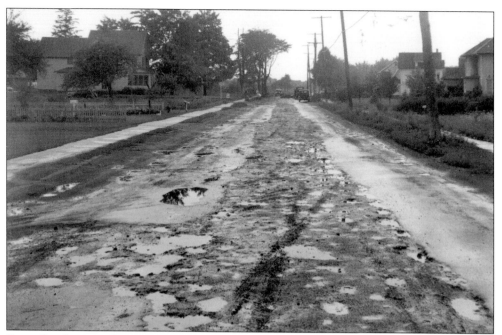

Stone Road appears here in 1934 before road construction. The street is named for the Stone family of Greece, not the Stones of Rochester, Pittsford, Brighton, or Brockport.

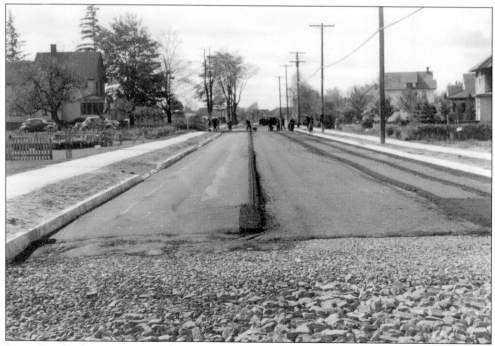

Stone Road is being constructed.

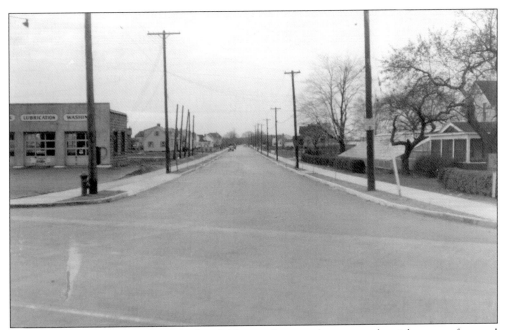

This section of Stone Road is completed. Notice the greenhouses on the right, one of several floral firms in the area.

This 1935 photograph shows another newly paved section of Stone Road. The cart on the right is probably a Radio Flyer.

The Flynn Road rebuilding project required the construction of two concrete bridges. About 400 feet of new road was built for one bridge approach and 100 feet for the other approach, eliminating a bad S-curve on Flynn Road. The old S-curve is on the right. For many years, an old fishing shack near the curve had hosted spirited card games and offered tobacco, booze, and boat rentals. What else could a fisherman want?

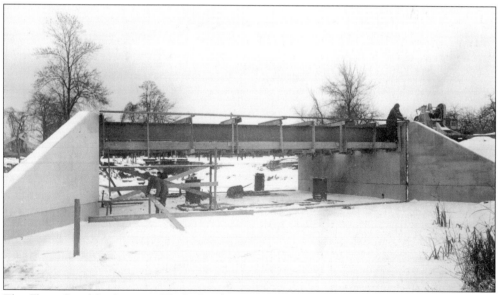

The Flynn Road bridge over Black Creek was 29 feet wide, and the one over Smith Creek had a width of 16 feet. Jobs were needed constantly during this period of national economic depression, so even wintery weather did not slow down construction work.

Weiland Road is shown before construction in 1934 near a crooked farm lane on the left. Post Avenue was also improved, and a 193,500-cubic-foot storage building was built on Dewey Avenue to provide storage space for the City of Rochester Department of Public Works equipment.

Weiland Road is pictured here after it was widened and completed. Note the high electric poles and the shorter telephone poles. The road in the foreground is probably Ridgeway Avenue by the old Native American campsite at the top of the hill. The hill is part of the high gravel ridge known as the Niagara Escarpment, where 7-foot skeletons of Native Americans were found during highway construction. A geological feature formed by an ancient glacier, the ridge extends to Niagara Falls, where the Niagara River spills over the escarpment.

Denise Road is shown before it was paved by a Works Progress Administration program.

After paving, the improvement was obvious.

This image shows another completed section of Denise Road. Gordon Howe was among the students from this area who attended Charlotte High School.

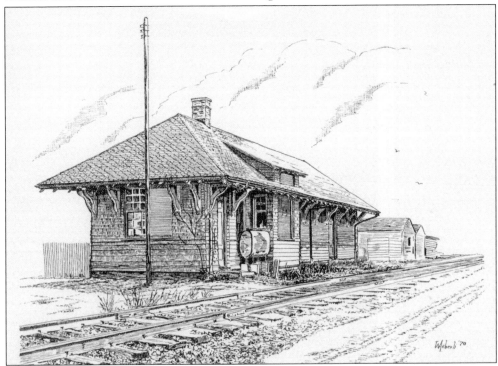

Along Dewey Avenue, James Vick's nurseries once flourished on what is now the grounds of St. Joseph's Villa. The community around Vick's nursery grounds and Thomas Barnard's farm where Dewey Avenue crossed the railroad is still known as Barnard's. William Aeberli's sketch shows the Barnard's Crossing station, located in an area sometimes called Pretty Girls Crossing.

The Barnard Fire Department originally met at the Old Dutch Mill, but in 1938 built the Barnard's Exempts Club off Maiden Lane, where many banquets and private dinners have been hosted. The Greece Historian Office has preserved this view of the dining room at the club that the fire department members constructed.

Gordon Howe, Vincent Tofany, and Bill Gardner were among those at the head table at this 1983 Barnard Exempts Club dinner.

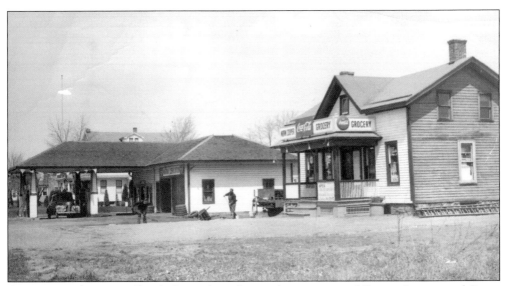

A gas station known as Essig's, located on the northeast corner of Dewey Avenue and Stone Road, advertised its address as Reed's Corners in the 1920s. An 1869 map showed Read's on Latta Road near Squire Nicholas Read's home. Later, this became part of the Mount Read post office area, extending perhaps as far as what is the Barnard area today. The Reid Block, the first modern shopping plaza in Monroe County, was built in 1928 adjacent to Norman Cooper's businesses. Cooper opened his gas station at Barnard's in 1942. In 1948, he remodeled the former Christiene farmhouse next-door for use as his store.

Norman Cooper, Charles Leise, and Harold Defendorf are seen here in Cooper's gas station.

Barnard's children loved Norm Cooper's custom of giving away a bicycle every year to one lucky winner and enthusiastically gathered at his station for the drawing.

Norm Cooper is pictured here with a lucky bicycle winner. Note the many advertising signs. Marty Reichenberger's store and McBride's gas station, store, and bar were on the southeast corner across from Leon Cox's Old Dutch Mill, a restaurant and bar that Cox later expanded into the New Dutch Mill. Behind the Old Dutch Mill, Barnard's summer carnivals were held.

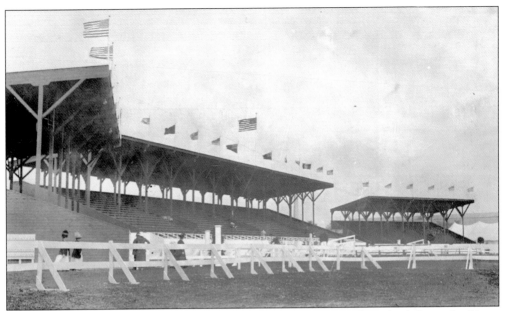

On the city end of Dewey Avenue, Edgerton Park's stadium, racetrack, and exhibition buildings provided entertaining events that attracted many local residents, as did Holleder Stadium near Ridgeway Avenue, which has been demolished. The old wooden grandstand built at Edgerton in 1913 (shown here) was improperly located; the sun shone in the audience's eyes.

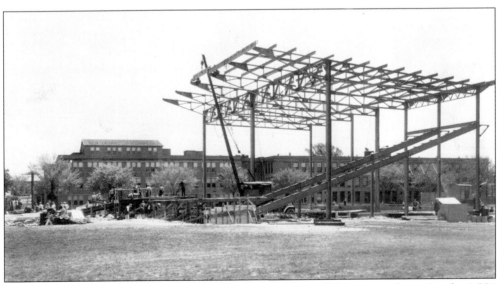

A steel Edgerton Park grandstand was under construction in 1934 to provide seating for 4,004 individuals. Similar grandstands were built at the Bay Street ball park and Red Wing Stadium on Norton Street. Francis H. Carroll was the chief engineer for the new stadiums and for 234 other projects undertaken in 1934 by the Rochester-Monroe County Emergency Work Bureau. Federal funds from the Civil Works Administration provided a total funding of $7,045,938.05, while providing employment for 16,000 workers during the Great Depression.

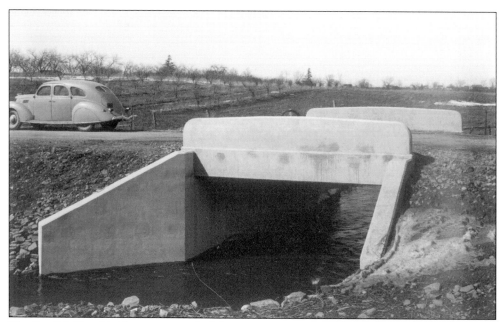

The English Road bridge was typical of those supporting the new hard-surfaced roads built in the 1930s to accommodate automobiles. Cars had often become stuck and marooned on the muddy unpaved roads of yesteryear, resulting in the county's 1931 Good Roads Program to pave nearly every road. By the 1940s, only a few dirt roads remained. In 1978, the town's first historical center opened in an English Road house beside a small town park.

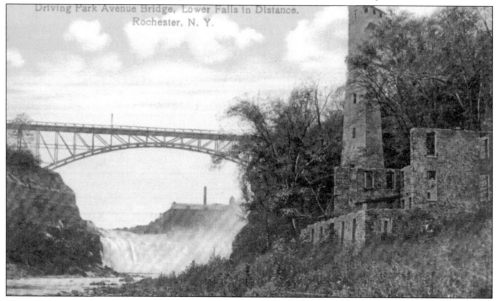

Beautiful rose gardens now grow on the onetime site of a riverside beer garden. At this site on a landing, far below on the riverbank, fleeing slaves boarded ships bound for Canada during the Underground Railroad era. Later, a high elevator tower was built to transport travelers to and from the Glen House Hotel or visiting steamboats. The Driving Park Avenue Bridge was an elaborate metal structure, carrying traffic across the river to the popular Driving Park's horse races. One end of the racetrack still remains as a curve on Park Avenue in Rochester.

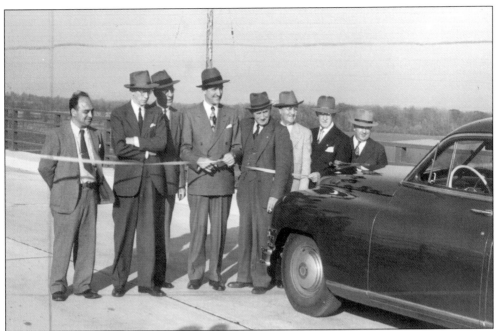

With County Manager Clarence Smith at his side and other town officials looking on, Gordon Howe officiates at a ribbon-cutting ceremony opening the new high-and-wide Manitou Road bridge over the Erie Canal. It offered a sweeping view of fertile acreage that once had been Hart & Vick's test gardens—land that is now part of Greece Canal Park.

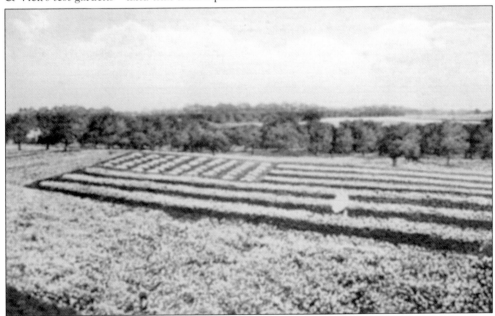

During World War I, James Vick's firm named a new aster variety "Heart of France" and created a mammoth American Flag by planting 135 acres of these asters in the midst of their fields beside the canal in 1918. It was quite difficult to weed, but drew crowds of onlookers every week. It became such a landmark that postcards were sold showing the gigantic flower flag. Pictured here is a copy of one such postcard from the Greece Historian Office.

Four

MANITOU MEMORIES

In 1822, the same year that the town was separated from Gates, the north end of Manitou Road was surveyed. It connected Ridge Road to Hick's Point, later renamed Manitou Beach. There, Samuel Hicks grew corn along the lakeshore and trapped and hunted game, which he sold to many residents. Many descendants attended the picturesque Parma and Greece United Church of Christ, built on land donated from the Chase farm. The Reverend Alexander MacKenzie, pastor of the nearby Parma-Greece Christian Church, bitterly opposed the erection of the hotel because he thought a bar would become a bad influence in North Greece, attracting gamblers and alcoholics. His pleas failed. A subsequent pastor, the Reverend Robert Hathaway, spent many years of his pastorate compassionately counseling Rochester's alcoholics. His hopeful message was that no matter how bleak things may seem, life tomorrow may be brighter.

The Hicks, Chase, Bulger, Feil, Edington, and Northrup families annually held well-attended Chase family reunions at Manitou Beach. This photograph, one of a series of six taken at the same reunion, shows the James Chase family.

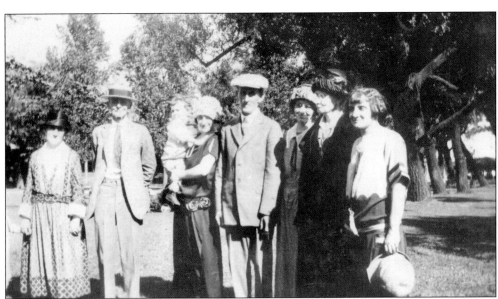

These are the members of the William Chase family at the reunion. Isaac Chase Sr. was a Massachusetts Quaker who emigrated with his family from Greenfield in Saratoga County, New York. Three times elected supervisor of Parma, he was well known for his activities aiding the Underground Railroad. His brother-in-law, Samuel Odell, a Charlotte storekeeper, received runaway slaves from Chase's house and assisted them in boarding boats to Canada.

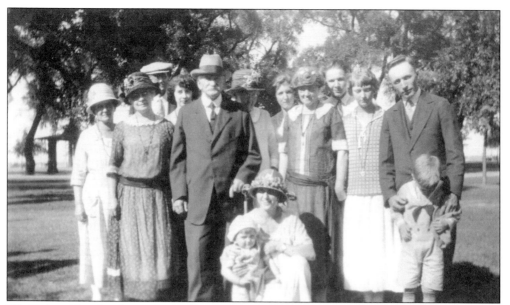

Ella Feil and her family are shown here.

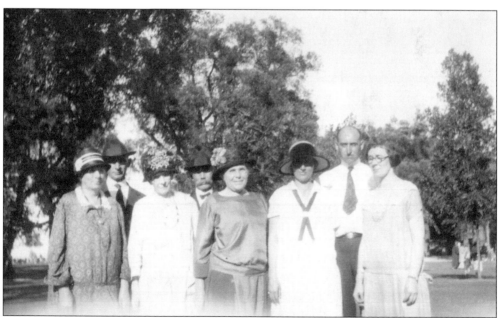

Shown are descendants of the Bulger family. Isaac Bulger and Jesse Brown of Manitou Road were the first Parma Grange members to circulate a petition seeking a rural mail route. America's Grange organizations sought home mail delivery so that farmers would not have to take time off from their labors to go to the post office.

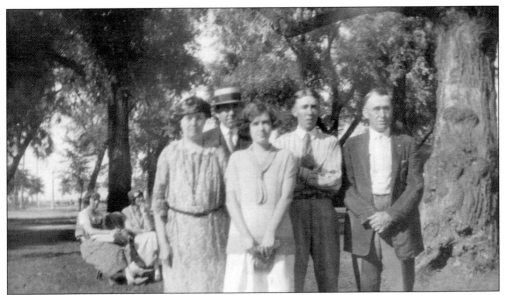

Maurice Northrup, fourth from left, is among the Northrup family members posing at the Chase family reunion.

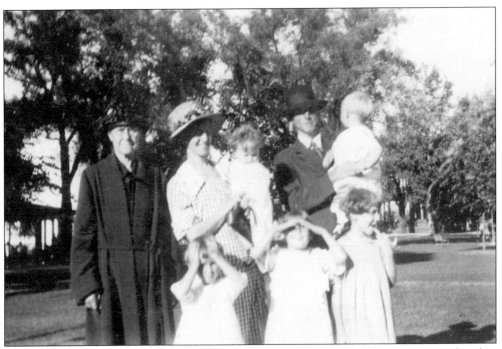

Hicks family members, including those shown here at the reunion, would always remember that their relatives had once owned the land at Manitou Beach, where the reunions were usually held for sentimental reasons. Descendants of this family are now found as far away as California. Noted artist Edward Hicks is among their antecedents. Samuel Hicks came from Lanesboro, Massachusetts, and others came to Manitou Road from New Hampshire.

This view looks down Burritt Road toward the Northrup farm on Manitou Road. The Hicks barn was destroyed in a near tornado that struck the area in 1974, damaging properties and trees from Route 259 to North Greece Road. Greece lies in a tornado zone, although no real tornado has ever hit down here.

Although the 1974 windstorm caused much damage to the homes and trees in North Greece and on Manitou Road, Peck Road, and Route 259, there were no serious injuries.

An attempt to create a bay side village on the west side of Braddock Bay in Parma and Greece failed in the 1790s because a form of malaria transmitted by mosquitoes breeding in the marshes plagued settlers with the notorious Braddock Bay Fever. Three bridges cross the bay wetlands in the area once called Hiscock's Mills, but now known as the Bridges. A few homes and drinking establishments line the bay side. In that area were built the homes of the Hiscocks, the Blodgetts, and the Burgers. Housing for mill workers at Clark's lumbermills (later operated by the Hiscocks) and a new Skinner homestead were also built there.

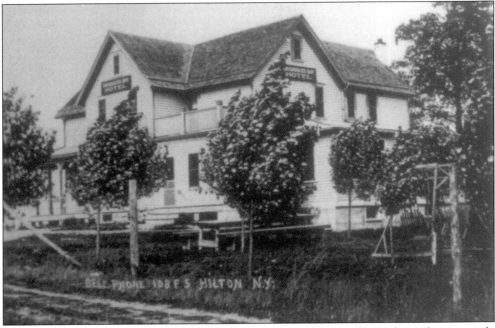

The Braddock Bay Hotel still serves tasty fish dinners on the site at the Bridges, where an early writer said "a rum hole has existed from time immemorial." The hotel enjoyed a respectable reputation when on Sundays, a procession of cars brought customers there for dinner, following services at the Hilton Baptist Church—much to the delight of proprietor Cora Smith. The Greece Historian Office preserved this photograph.

The Skinner name means "the skinner, a dealer in skins." Hunting raccoons was a favorite recreation for Sheriff Skinner, but those who took trapping seriously could make a bit of money selling muskrat, fox, and raccoon skins. Others caught fish, frogs, and eels, using huge nets to pull hundreds ashore. Ice was harvested in winter and stored in sawdust-filled icehouses to preserve it for summer use. The Blodgetts were among those who harvested reeds from the marshes, selling them for caulking barrels or making woven chair seats. Children earned prizes selling Larkin's soap products, each of which contained a trading card. One such trading card is shown at right. The brightly lithographed cards were eagerly collected and traded by all ages.

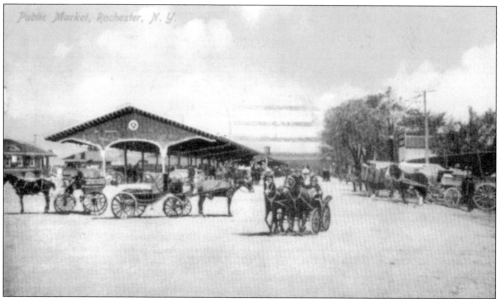

When Ward Cox and George Burger lived on Manitou Road, they sometimes caught frogs in the bay, taking wagonloads of them to Rochester for sale at the public market. Some were sold to Odenbach's Peacock Lounge and other Rochester restaurants. Greece's many market gardeners also sold produce at the market. Lettuce, onions, carrots, celery, and other salad vegetables were grown on Maiden Lane Road and elsewhere in the Dewey-Stone area.

Skinner's Hotel—built in 1853 beside Braddock Bay near the sand spit across the lakeshore—was the first hotel to be built by the bay. There, two generations of the Skinner family were born. Its last occupants were the Fauding Skinner family, who lived in the house until 1902. Fishermen would sometimes steal Mrs. Skinner's pies as a prank when she put them on a window sill to cool. Besides boat rentals and bait, cigars were sold.

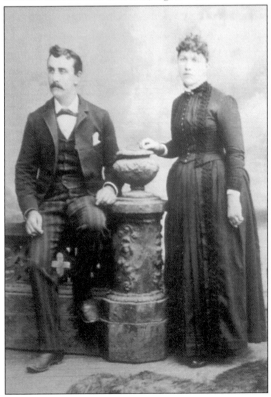

Roswell Bellows Skinner and Nellie Buell were founders of Skinner's Hotel.

104

As children, Anna and Albert Skinner lived in the old hotel. Albert achieved distinction when he was elected sheriff of Monroe County. Anna served for many years as his housekeeper and jail matron at the county jail, where both lived for many years.

Near Payne Beach, young Albert Skinner found a job caring for Haslip's horses. Haslip's training track was located on the east side of Manitou Road, north of Manitou Beach Road, the highway that led to Manitou Beach.

The Charles Skinner family's Arlington Hotel at Hilton stood adjacent to the Hojack's railroad tracks. Charles Skinner worked at the Manitou Beach Hotel and also at the family's Arlington Hotel in Hilton, shown here.

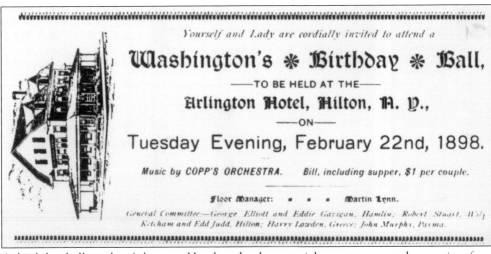

A birthday ball at the Arlington Hotel and other special events attracted attention from surrounding areas.

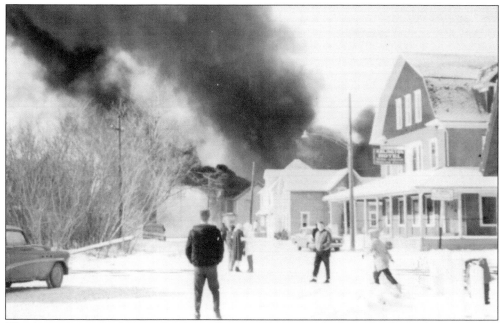

Thanks to the work of Barnard and North Greece firemen, who kept the flames from spreading all the way down Hovey Street, the Arlington Hotel escaped the 1965 fire that burned away much of the north side of Hilton's Main Street and several Hovey Street homes. Losses would have been far greater without the assistance of firemen from Greece and surrounding areas.

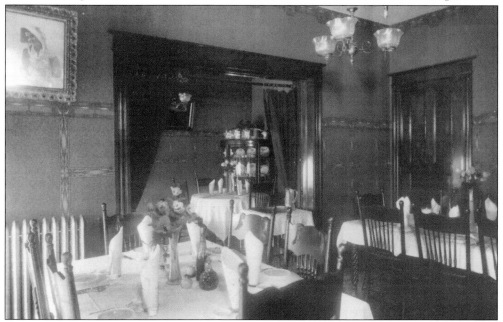

Fish dinners on Friday have always been delicious meals served with éclat at the Arlington Hotel's immaculate dining room, typical of that era of gracious dining. These dinners are still a tradition at the recently built Arlington. An old business ledger reveals that nine people—some male, some female—were engaged by the Arlington as hotel help in the evenings, with a total outlay of $2.50 for salaries.

The five Skinner brothers together weighed 1,375 pounds when this picture was taken at a family reunion, c. 1928. They are the sons of Roswell and Nellie. In the rear are George, Will, and Faulding. Louis and Frank are in the front. Faulding loved to entertain children with fanciful stories of a great lake storm that washed the hotel from the sand spit to a new location at the west end of the bay. His tales of gold buried by a fictitious Captain Braddock convinced many to become money diggers, but no gold was ever dug up. Faulding was Albert's father.

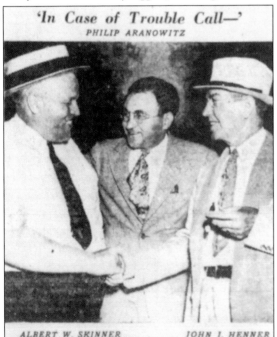

'In Case of Trouble Call—'
PHILIP ARANOWITZ

ALBERT W. SKINNER JOHN J. HENNER
After the first of the year one of these three men will be at the
Monroe County jail ready to answer unusual emergency calls. The
three opposing candidates for the post of sheriff were snapped in
this friendly pose in the lull before the election storm at the super-
visors' picnic at Point Pleasant yesterday. Skinner is a Republican,
Aranowitz, "the lone wolf of the Seventh Ward," an independent,
and Henner a Democrat.

The three candidates seeking election to sheriff are shown at the annual supervisors' picnic at Point Pleasant in 1937. Albert Skinner (left) ran on the Republican ticket. Philip Aranowitz of the Seventh Ward ran as an independent, and John J. Henner ran as a Democrat. Until that year, sheriffs served for only one term, but a change in the law was fortuitous for Al. He remained in office for 36 years.

Skinner's considerate and compassionate manner won him recognition across the state. His horse patrol became widely known, even though he had to buy the first ones himself, purchasing two former Troop D state trooper steeds. This July 2, 1940 newspaper article shows Dep. Arthur Kay and Dep. Sam Raab riding the handsome horses that had once been part of a circus troupe. The Morgan horses were a sorrel and a buckskin, half brothers.

JULY 2, 1940

Ready to Gallop Off on New Patrol
DEPUTY ARTHUR KAY DEPUTY SAM RAAB

To a great Sheriff
Pat Di Gennaro
Duke Rodney

The Futurity
Yonkers
1961
2:01

Al's love of horses was well known and remembered by Pat DiGennaro and Duke Rodney, who sent him this autographed picture of their race in the Futura at Yonkers in 1961.

Skinner knew that mounted officers were the best source of crowd control. He also initiated the use of uniforms for his deputies and was the first to use a squad car. This motorcycle escort of sheriff's deputies awaits the arrival of Pres. and Mrs. Richard Nixon at the Rochester airport in 1970. Another escort of deputies solemnly provided an honor guard at the sheriff's 1979 funeral.

A crowd of friends came to Parma Union Cemetery to pay silent tribute to the long, successful career of the quiet, popular Braddock Bay boy who had graduated from Hilton High School, worked at the Hilton canning factory, and eventually found an important career in law enforcement. Here, Sheriff Skinner's casket is being taken from the Greece Baptist Church.

The patrol was continued in later years; its blonde palomino horses, known as "the Sheriff's Horses," were very popular as they led area parades. There was scarcely a dry eye as his favorite palominos accompanied Skinner's casket to his last resting place in Parma Union Cemetery.

The riderless horse symbolizes a lost leader.

Albert and Anna Skinner lived in an apartment at the county jail during much of Albert's term of office. Earlier, before corporal punishment laws changed, three prisoners had been hung in the central cell block, where all could witness their punishment. Al used a more humane approach, bringing coffee, doughnuts, and cigarettes to suspects. He considered the most important moment of his career to be the conviction of James Moore, the killer of Pamela Moss.

The sheriff's garage and the Exchange Street jail are seen here from the rear. The old Rochester police headquarters on Exchange Street was vacated in July 1963 and demolished. A new jail in the public safety building housed all prisoners, but soon became overcrowded. In later years, under the leadership of popular sheriff Andrew Meloni, additional law enforcement buildings were added adjacent to the Monroe Community College campus.

Available for riot control, this group of determined National Guard members is seen in downtown Rochester, near the Court Street dam in 1984. They were never used because law and order was successfully contained by the city police department during the 1984 racial riots in Rochester. The Skinner family motto is *Numquam non paratus*, "never unprepared."

The National Guard camped at Genesee Valley Park during the July 1984 racial riots. County Manager Gordon Howe stood by at the National Guard's headquarters at Cobb's Hill Park. After the riots, local businesses and government representatives worked diligently to provide better jobs, housing, and education for the underprivileged.

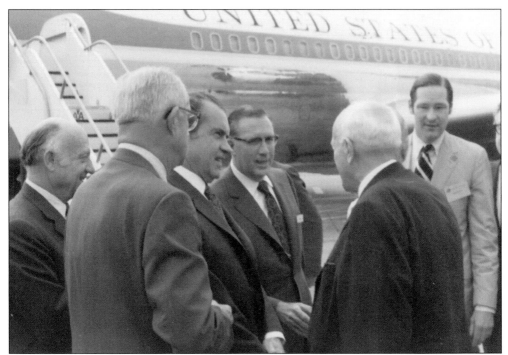

In 1970, Skinner greets Carl Hallauer, Sen. Jacob Javitts, Pres. Richard Nixon, Rep. Frank Horton, Rochester Mayor Steven May, and Gov. Nelson Rockefeller at the new county airport. Gordon Howe and other prominent Republicans were also in the welcoming party.

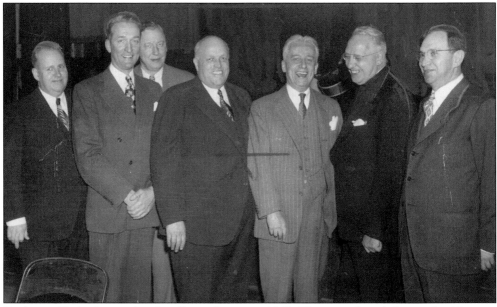

Rochester Eagles honor the sheriff at a dinner in 1949. They are, from left to right, Norman Husbard, Greece Supervisor Gordon Howe, Edwin Wildey, Sheriff Skinner, Sen. Kenneth B. Keating, the Reverend Albert J. Geiger, and Joseph Kaufman of the Tenth Ward. Skinner received a great number of plaques and honors during his long career.

Sheriff Skinner cuts the cake at the celebration of his birthday on November 13, 1972. Gordon Howe and county Republican chairman Richard Rosenbaum look on.

Parma Republican Women hosted a dinner honoring Sheriff Skinner and Undersheriff Fenton Coakley in 1971. The day was proclaimed "Albert Skinner Day in Hilton" as part of a program commemorating Monroe County's 150th anniversary. Perry and Ethel Dunn are seated on the far left. Standing behind the sheriff are, from left to right, George Bremner, Dottie Bremner, William Dwyer, Caroline Hurlbutt (wife of the village mayor), Leona Fetzner Coakley (wife of the undersheriff), and Elizabeth Hurlbutt (the mayor's mother).

Undersheriff Fenton J. "Fent" Coakley, seen here as a child, was always photogenic.

Fent is shown here as a young man with his dog.

This picture of the Coakleys was taken at Manitou Beach

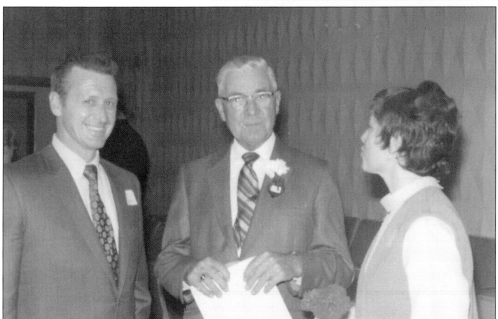

Fent (center) is shown here with his daughter, Kathleen, and son-in-law, Roy Hershey, at the Parma award dinner. This photograph was taken by the Reverend I. Vincent Lloyd.

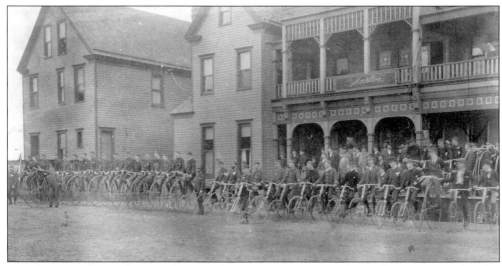

One day Hampden Hyde, a Rochester judge's son, was sailing in the Hick's Point area when his boat capsized. He swam ashore, explored the beach, and decided that it would be a fine place to build a hotel since it was within bicycling distance from Rochester and was a fine place to moor boats. The new pneumatic tires had made bicycling popular. He convinced the law firm of Mathews and Servis to purchase the land and create a pleasure resort. One day more than 50 bicyclists wheeled there.

This trading card advertises a Rochester business, Mathews & Servis. James Mathews and Silas A. Servis purchased 70 acres in 1888 and began to develop Manitou Beach. It appeared to be good investment because the Grand View Beach Railroad had been chartered in 1888 and began operations on Memorial Day 1891. Although the peninsula had variously been known as Hick's Point, Rhodes Point, and Point Pleasant, the lawyers changed the name to Manitou Beach, adopting the name of Manitou Springs, Colorado, near Pike's Peak, where well-known resorts flourished by mineral springs.

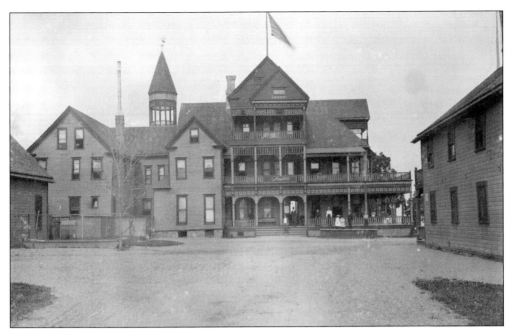

Because Manitou is a Native American term referring to a godlike spirit, Manitou Springs, "the Saratoga of the West," was considered to be a holy place where the spirit of God met mankind. Many went there for health reasons. With hopes for achieving similar popularity here, the gigantic new Manitou Beach Hotel opened on May 30, 1889, with 25 rooms available and three tiers of porches that provided customers with a bird's-eye view of the lake and the adjoining resort grounds. This is a rear view of the hotel as seen from Manitou Road.

By July 1889, a 2,000-foot wooden trestle had been built to carry passengers over Braddock Bay to Manitou Beach. It was one of eight trestles. There were then very few cottages west of Long Pond, but soon summer residents were happily living in tents or cottages along the line. This image was provided by the Greece Historian Office.

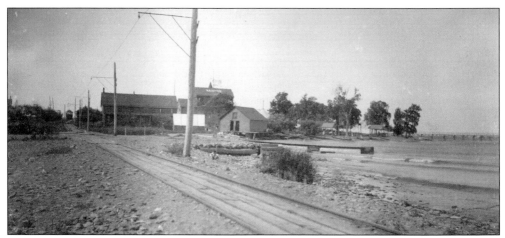

From 1891 to 1924, as many as 16 trolley cars a day brought passengers on shoreline excursions to and from Rochester. It was a picturesque 16-mile ride for a mere 25¢ (round-trip) and a gentile ride for ladies, since anyone who was drunk was quickly escorted off the cars with what then was known as "a bum's rush."

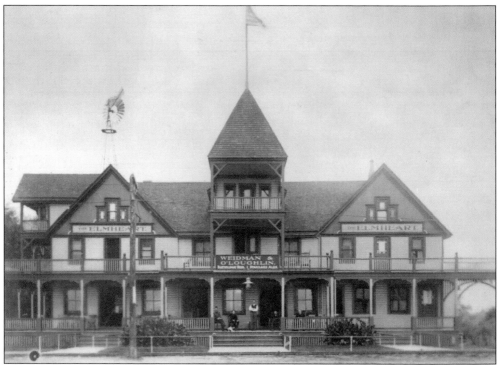

Jacob Odenbach purchased 16 acres west of the Manitou Beach Hotel in 1890 and began building the 24-room Elmheart Hotel. It was completed in 1892, but ownership of the land was claimed by the Skinners. Following a court decision in 1894, Odenbach lost his new hotel. To prove ownership, Roswell Skinner cut down a tree that he believed marked the boundary. In the heart of the elm's trunk was found the scar made by a surveyor's axe. A section of the trunk that proved Skinner's case in court in 1894 was kept in the hotel for nearly a century. It was given to the Greece Historical Society for preservation before fire destroyed the hotel in 1992. This picture of the Elmheart is on file in the Greece Historian Office.

Fenton Coakley stands before the Colony Club's welcome banner, inviting the public to dance in their dance tent or picnic in their pavilion beside the Elmheart Hotel. The Old Colony Club tents are seen in the background; they were built alongside wooden boardwalks under which the waters of Braddock Bay sometimes washed during lake storms. At least 250 men came from Pittsburgh each summer to frolic at the beach. The Elmheart barkeeper noted that once they arrived, "they never drew a sober breath!" After camping at Wautoma Beach and Cranberry Pond, they eventually chose Manitou as their favorite location and came there every August for more than 10 years.

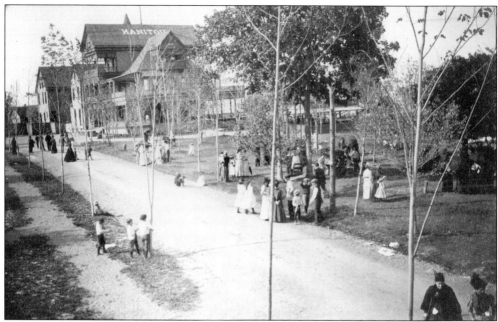

The Grand View company was foreclosed in 1895 and was succeeded in just two weeks by the Rochester, Charlotte, and Manitou Beach Railway. An extension to Hilton planned in 1898 and another to Devil's Nose in Hamlin were never built, as financial difficulties continued. By 1900, as many as 4,000 people a day came on the trolley. It was not unusual for 7,000 visitors to be at the beach on weekends.

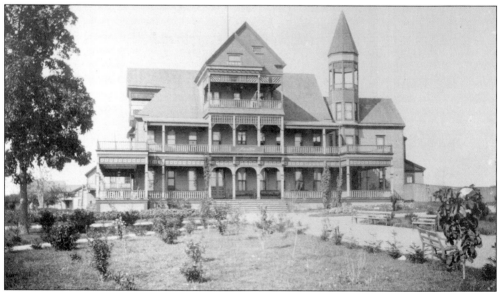

On November 15, 1901, Estelle J. Odenbach purchased 70 acres of land around Manitou Beach Hotel, and a plan for a cottage development was mapped out in 1902. In 1904, Fred Odenbach bought the hotel Manitou and the four-year-old steamboat the *Rosalie*, which brought passengers along the lake to the hotel docks. The hotel's dining room accommodated at least 500 customers. While run by Fred Odenbach, fish dinners (75¢) and roast beef dinners (60¢) were popular menu items. This is the view from the lake.

There was a marvelous French electric fountain, and special exhibits were often featured, such as the Royal Japanese Temple sent direct from Tokyo. A large hitching shed was maintained for those who came by horse-drawn carriages. Diagonally opposite the hotel, a house was built for hotel workers. The end of the line was at a small trolley station near the hotel. There, the cars turned around to return to Rochester. Trollies ran every 15 minutes from early morning until late at night. Dogs rode free.

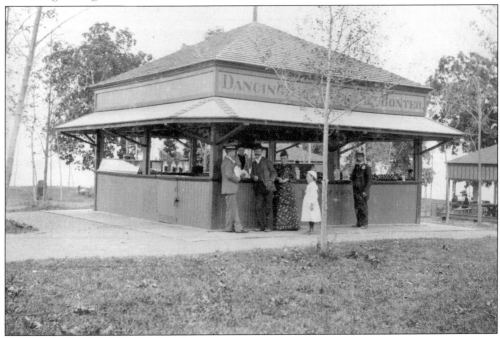

A refreshment stand on the beach sold popcorn, peanuts, ice cream, soft drinks, and candy. A two-story dance hall with a barroom was built adjacently. Orchestras came from New York, Philadelphia, and other cities to play at Odenbach's dining room and at the nearby dance hall. Benny Goodman, Jimmie Lunceford, Cab Calloway, and Vincent Lopez were among the big-name bands that once played at Manitou Beach.

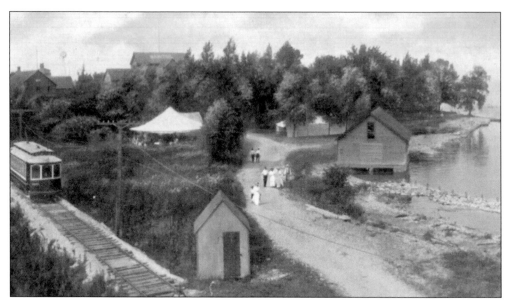

This view shows Manitou Beach as seen from a trolley car approaching the area. The "Manitou" advertising sign on the shingled roof of the hotel competed for attention with another roof sign reading, "Manitou Lunchroom," at the dance hall. The Elmheart Hotel next-door offered rooms as well as refreshments. Boats could be rented, and there was a water slide by the bathing beach. Church picnics, family picnics, company picnics and the popular Old Farmer's Picnic, begun in 1894, often brought enormous crowds to Manitou. They came there by trolley, on foot, on horseback, or by wagons, carriages, or automobiles.

Both the Colony Club's dance tent and William Reis's merry-go-round (5¢ a ride) were under huge canvas canopies, each topped by a lightning rod. Ever conscious of the danger of fire, proprietors also topped the wooden structures with lightning rods, knowing that a fire could be disastrous. If you could not afford the 25¢ admission to the dance hall, you could dance free under the Colony Club's canopy or enjoy their twice-weekly movies.

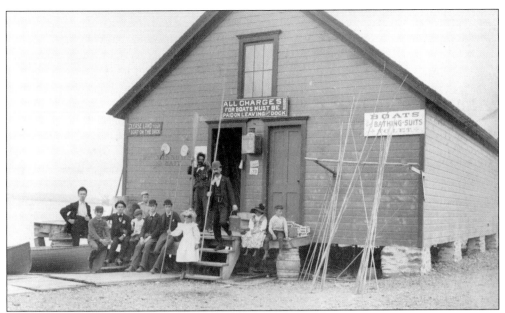

Albert and Anna Skinner sit on the far right in this view of Skinner's boat livery. This charming photograph and eight others reproduced here from the Hilton village historian's files, were probably taken by the talented Albert Stone, a Rochester photographer. The images were in Al Skinner's private collection. After his death, Skinner's former driver, Maurice VanDorn, gave them to the village for preservation.

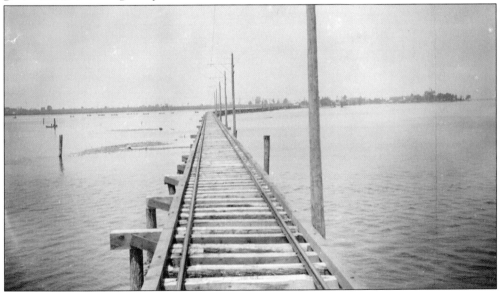

Although more than 233,000 customers rode the rails in the fiscal year from 1906 to 1907, the trestles were rotting away and dangerous. A bad lake storm resulted in a washout of track at Rigney's Bluf and the destruction of the trestle over Braddock Bay and other trestles forced foreclosure again. By August 1908, the company went bankrupt; it was reorganized within two weeks as the Rochester and Manitou Railroad. Two construction workers were drowned when a sudden lake storm swept the workmen off the rails as they worked on the bay trestle. This photograph is used here courtesy of the Greece Historian Office.

The advent of automobiles ended to the story of the shoreline trolley. As cars took passengers to resorts afar, ridership dwindled. In 1925, its cars, tracks, and buildings were finally sold for $40,000. After the tracks were removed, only a few rotting wooden piles in the bay remained as a silent, sad reminder of the wonderful trolley. The Farmers Picnics were canceled after the trolley stopped running, and Manitou Beach Hotel finally closed in 1941. The old Skinner hotel went up in flames, struck by lightning. After a fire damaged the interior of Odenbach's hotel, the building was finally demolished and replaced by a modern house built by William Kaiser.

Barns, an icehouse, and other buildings stood east of the hotel. Around 1902, Mike O'Loughlin and his nephew, George Weidman, had become the hotel proprietors. Card games were a popular event in the barroom, but only a few families still came for picnics on the sand spit to which George charged a small admission fee. Upstairs rooms that had once been rented by the day or hour were no longer rented after 1931. Few came to watch the magnificent purple, gold, and cerise sunsets over Ontario's silvery waters. Children no longer hunted for shells or shrieked when bloodsuckers crawled between their toes. But George Weidman kept the bar open until his death in 1986, marking the end of an era. This is a Greece Historian Office picture.

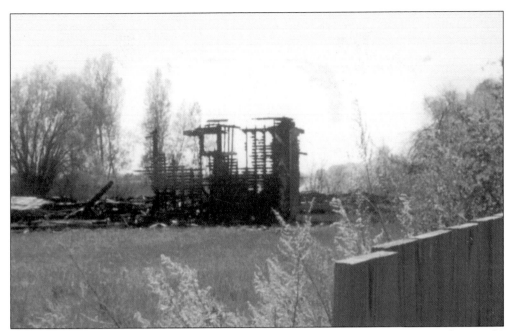

A suspicious fire destroyed the abandoned hotel in September 1992. Flames were leaping 30 feet into the air when firemen arrived there about 1 a.m. On May 19, 1995, the dance hall also became subject to vandalism and burned down (above) on May 19, 1995.

These ruins of the famous Manitou dance hall are all that remained after the disastrous fire that Lake Shore, Hilton, and Walker firemen battled in vain. Greece police were on duty as firemen valiantly fought the flames, but managed to save only the outbuildings. Now only memories remain of the dance hall, refreshment stand, water slide, boat rental, merry-go-round, hotels, and trolley buildings at Manitou.

A private home graced the former Manitou Beach Hotel grounds by the 1990s, a mansionlike showplace along the sandy shore where thousands of visitors had once enjoyed the bucolic glories of Manitou Beach. This 1979 aerial view from the Greece Historian Office shows the aisle of lofty Lombardy poplar trees that once lined Manitou Beach Road. Their breathtaking silhouette against sunrise and sunset skies is now only a memory.

Shore birds still fly along the beautiful lake, and quiet peace prevails. This scene is from a diorama made by the Rochester Museum of Arts and Sciences. They identified 13 species of beach birds, including sandpipers, plover, sanderling, yellowlegs, and terns (sea gulls). Perhaps, it is poetic justice that once again Mother Nature has taken over the ancient, historic sandbar beside the bay.